# YELLOWSTONE

## IN PHOTOGRAPHS

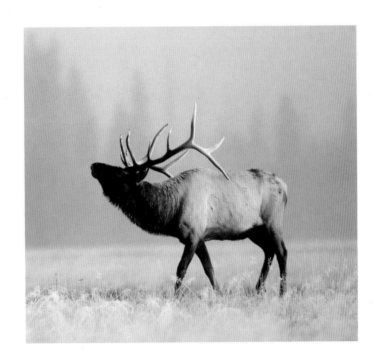

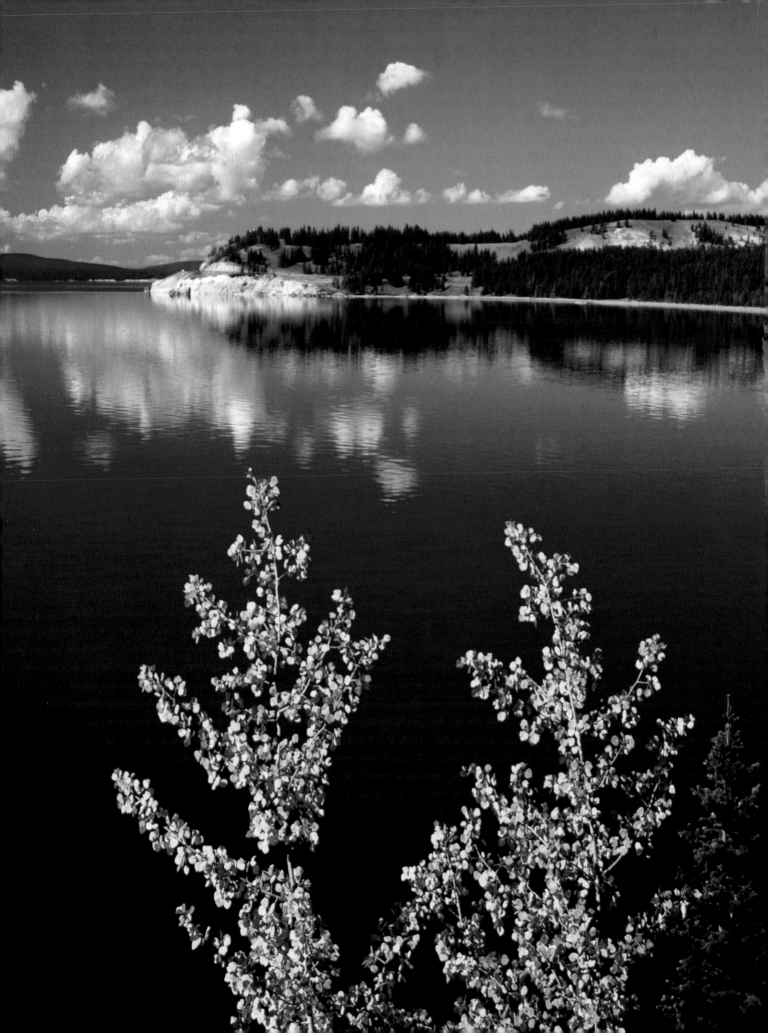

# YELLOWSTONE
## IN PHOTOGRAPHS

George Wuerthner

**GRAMERCY BOOKS**
New York

© 2005 Salamander Books,
151 Freston Road,
London W10 6TH

An imprint of Anova Books Company Ltd.

Published by Gramercy Books, an imprint of Random House Value Publishing,
a division of Random House, Inc.,
New York, by arrangement with Anova Books, London.

Random House
New York • Toronto • London • Sydney • Auckland
www.randomhouse.com

Printed and bound in China

A catalog record for this title is available from the Library of Congress.

ISBN 0-517-22705-3

10 9 8 7 6 5 4 3 2

## Credits

Editors: Katherine Edelston and Shaun Barrington
Designer: Helen Garvey
Picture Researcher: Rebecca Sodergren
Production: Alice Reeves
Reproduction: Anorax Imaging Ltd

## Additional captions

Front cover: Castle Geyser erupting.
Page 1: A bull elk bugling during the autumn rut. A single bull will attempt to
collect and breed with a harem of up to 30 cows.
Page 2: Underneath the tranquility and beauty of Yellowstone Lake lies a
hotbed of geothermal activity.
Page 5: (Left) A moose watches over her calf. (Middle) Fireweed inhabits
many areas of the park that have been subject to natural fires.
(Right) The Greater Yellowstone Ecosystem boasts the largest
herd of bison in the world.
Back cover: Gardner River from the air.

## Picture Acknowledgements

T= Top   B= Bottom   C=Center   R= Right   L=Left

All images © George Wuerthner apart from the following:
© **Alamy Images**: © Terrance Klassen/Alamy 24. / © A M Corporation/Alamy 28T.
© **CORBIS**: © Ric Ergenbright/CORBIS 2. / © Jeff Vanuga/CORBIS front cover, 14-15. / © Darrell Gulin/
CORBIS 20-21. / © Michael T. Sedam/CORBIS 23. / © Scott T. Smith/CORBIS 40-41, 42, 79. / © Jason
Hawkes/CORBIS 45, back cover. / © Pat O'Hara/CORBIS 54. / © Terry W. Eggers/CORBIS 60. / © Raymond
Gehman/CORBIS 70. / © George D. Lepp/CORBIS 74. / © Darrell Gulin/CORBIS 82-83, 86-87.
© **Frank Lane Picture Agency**: © Michael Quinton/Minden Pictures/FLPA 1, 90, 91, 94. / © Shin Yoshino/
Minden Pictures/FLPA 5C, 8. / © David Hosking/FLPA 6, 9, 12-13, 16-17, 17B, 25, 28-29,32, 32T, 33, 44, 45,
50T, 50-51, 57, 58, 62-63, 65, 67, 85. / © Mark Newman/FLPA 12. / © A Jones/Dembinsky/FLPA 34.
© Martin Withers/FLPA 37. / © M Newman/FLPA 72. / © Carr Clifton/Minden Pictures/
FLPA 77. / © Tim Fitzharris/Minden Pictures/FLPA 80, 95.
© **Photolibrary.com**: 27, 36, 52-53.

# CONTENTS

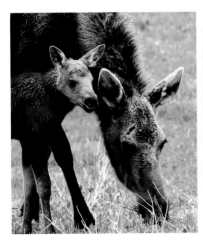
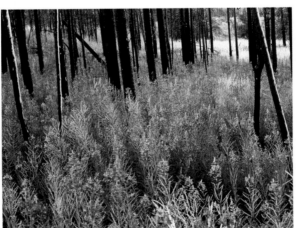
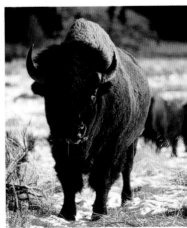

# THE MAGIC OF YELLOWSTONE

If there were only one place left on Earth that could be called magical, Yellowstone National Park would have to be it. With its hot springs, geysers, rugged mountains, flowery meadows, and abundant wildlife, a visit to Yellowstone is never the same, no matter how many times you may go back. I've been visiting Yellowstone for more than 30 years, in all seasons, and some years I've spent months at a time in the park and I never grow tired of returning. With familiarity comes intimacy, so that every new journey into the park is both an affirmation of past experiences, as well as a door opening to new and yet undiscovered wonders.

The magical aspects of the park are easy to understand when you consider some of Yellowstone's superlatives. The world's first national park, it was until recently, the largest national park in the lower 48 states (Death Valley National Park now claims that status) and is the centerpiece for the 18 million-acre Greater Yellowstone Ecosystem. It has the greatest concentration of thermal features in the world and is one of the most seismically active places in the entire United States with thousands of earthquakes recorded annually. Yellowstone Lake is the largest high-elevation lake in the U.S. And Yellowstone also claims the largest backcountry lake in the lower 48 states—the 8,000-acre Shoshone—completely inaccessible by road. It is home to the largest wild bison herd in the world. And the park possesses the last major stronghold for the endangered Yellowstone cutthroat trout, as well as grizzly bear and wolf in the western United States. This region, though not unaffected by human activities and development, is still among the largest relatively intact temperate landscapes in the world. Yellowstone's global importance is appreciated worldwide, and the park is officially recognized by the United Nations as both a World Heritage Site and International Biosphere Reserve.

## GEOGRAPHY

Yellowstone is big—some 2.2 million acres—which makes it roughly two-thirds the size of the state of Connecticut. Since the park was established before any of the surrounding states, its borders overlap all three states—Montana, Idaho, and Wyoming—with the bulk of the park in Wyoming.

The headwaters of three major rivers begin in the Park, including the Missouri; the Yellowstone, which eventually drains to the Atlantic Ocean via the Missouri and Mississippi; and the Snake, which flows from the southern part of the park, eventually

*Below*

*The White Dome Geyser consists of geyserite deposited by the mineral rich waters during eruptions, which can rise to 30 feet.*

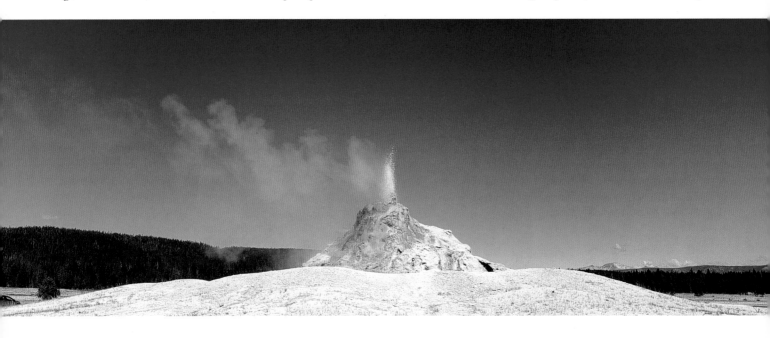

reaching the Pacific Ocean by way of the Columbia River.

Yellowstone is basically a high plateau surrounded by even higher mountains that tower to nearly 11,000 feet. The average elevation is 8,000 feet, so don't feel surprised if you are a bit short of breath while traipsing down a trail. The high elevation means the park receives a generous snowpack; the southeast portion of the park gets tens of feet of snow annually. By contrast the lowest elevation in the park is by Gardiner, Montana, and is extremely arid, receiving less than 10 inches of precipitation in the average year (by comparison Tucson, Arizona in the Sonoran Desert gets 12 inches of annual precipitation!). With such variation it's not surprising to learn that Yellowstone's vegetation ranges from alpine tundra on the highest peaks to sagebrush-greasewood desert near Gardiner. Most of the forested sections of the park are dominated by lodgepole pine, along with Englemann spruce and subalpine fir. Aspen, though not common, is the major hardwood and adds color to the park when its leaves turn golden in the fall.

Geographically the park can be divided into a number of subregions. The Gallatin Mountains make up the Northwest corner of Yellowstone. The Absaroka Mountains and Lamar Valley lie in the Northeast part of the park. The Southeast corner contains Yellowstone Lake and the southern portion of the Absaroka Mountains, while the Bechler River country and Pitchstone Plateau make up the Southeast section of the park.

The part of the park where most people will spend their days is the Central Plateau. This area is high elevation (average elevation 8,000 feet) forested uplands. The plateau consists largely of the collapsed caldera of the Yellowstone Volcano which erupted some 600,000 years ago leaving behind a deep, mountain-rimmed depression. Yellowstone Lake fills part of this depression. Among other well-known features of the Central Plateau are the Grand Canyon of the Yellowstone, Old Faithful Geyser Basin, and the Hayden Valley.

The Northwest corner is dominated by the Gallatin Range. The range rises above Gardiner to the highest peak, 10,969 feet, Electric Peak. The Gallatin Range runs from Holmes Peak in the south all the way to Hyalite Peaks near Bozeman. The range has a core of Precambrian igneous rocks overlain by more recent sedimentary and volcanic rock. About 50 million years ago magma erupted from several parts of the range, including Mount Holmes and Electric Peak. Today the Gallatin Range is one of the most popular parts of the park for grizzly bears, and hikers are only allowed into the area when in groups of four or more.

Above Gardiner and at the foot of the Gallatin Range lies Mammoth Hot Springs. The springs are made of travertine, a calcium carbonate formation, a kind of limestone. Limestone also makes up the Golden Gate, an area of tumbled chunks of rock on the road to Norris above Mammoth. The springs produce about 500 gallons of hot water a minute, and remain 163 degrees year round. The source of heat for the springs is a mystery since these thermal features lie outside of the old Yellowstone caldera, the source of heat for most of the geysers and hot springs in the park.

If you continue south on the road towards Norris you pass Bunsen Peak, an old volcanic neck, and then enter Gardner's Hole, a high mountain valley with the Gallatin Range visible to the west. Eventually you will pass over a low rise and enter the central Plateau. The road passes the Norris Geyser Basin with more than 180 thermal features including Steamboat Geyser, the park's tallest fountain, which can reach 380 feet into the air.

If you go east out of Mammoth on the road towards Cooke City, you soon reach Tower Junction where the turn for the Northeast Entrance and Lamar Valley is located. The Northeast part of the park is dominated by the high rugged peaks of the volcanic Absaroka Mountains. The Absaroka Mountains were heavily glaciated during the last Ice Age. A huge 90-mile-long glacier once flowed down Soda Butte Creek and the Lamar Valley to the Yellowstone River Valley, north of Gardiner. Evidence of this glacial passage can be seen near Junction Butte where there are numerous small ponds and glacial erratics left by the retreating glacier.

The Lamar Valley is considered the premier wildlife area in the park. In the open grassy valley one can usually find herds of elk, bison, pronghorn antelope, along with grizzly bears and wolves. This beautiful valley is one of the few large grasslands in the West that is not privately owned. Had Yellowstone Park not been established so early—largely before white settlement of the area—chances are good that the Lamar Valley would be part of some large private ranch rather than the most magnificent wildlife viewing area in the West.

From Tower Junction one can continue on the Park "loop" road past Tower Falls, and over Dunraven Pass on the shoulder of Mount Washburn, to enter the Central Plateau. Mount Washburn and the Washburn Range is part of the northern rim of the Yellowstone caldera. There is an old carriage road, now closed to cars but open to hikers, that leads from Dunraven Pass to the mountain's 10,000 foot summit for superb views of the entire park. When you reach the relatively level Central Plateau below Mount Washburn you can visit the Grand Canyon of the Yellowstone. The Yellowstone River has carved the 1,500-foot deep canyon through rocks softened by thermal heating, hence easily eroded. Two spectacular waterfalls, the 109-foot Upper Falls and the 308-foot Lower Falls, are found in the canyon. For

a thrill that is not likely to be forgotten, hike the steep switchbacks down to the lip of the Lower Falls, where you can stand inches away from the pulsing flow of the entire Yellowstone River as it leaps over the lip of the falls.

Beyond the Grand Canyon the river winds through the pastoral Hayden Valley. The valley is a curious anomaly among the forest uplands of the plateau. Dominated by open meadows, the Hayden Valley is an excellent place to see wildlife, in particular grizzly bear and bison. The meadows are produced and supported by a layer of fine-grained soils which favor grass growth over trees. The soils were deposited during the Ice Age when the area was originally a lake.

Beyond the Hayden Valley the loop road reaches Fishing Bridge at the outlet to Yellowstone Lake. In the past, throngs of fishermen lined the bridge to cast for big Yellowstone cutthroat trout. Eventually, fishing from the bridge was banned. From the bridge it's easy to spot dozens of the two-foot long fish finning in the clear water.

Yellowstone Lake and the Absaroka Mountains share the southeast corner of the park. The lake itself fills part of the old

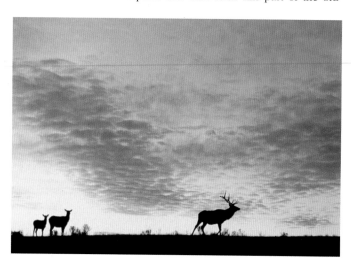

*The park is a haven for variety of wild animals including the elk pictured here in front of an iridescent Yellowstone sunset.*

Yellowstone caldera, so is technically part of the Central Plateau, but the south and southeast arms of the lake penetrate the high peaks of the Absaroka Range. The Upper Yellowstone River valley, above the lake in Yellowstone's southeast corner, is the most remote place in the lower 48 and the point furthest from a road—32 miles. If you go east from Fishing Bridge, the highway to Cody will take you to Sylvan Pass high in the Absaroka Mountains. Those interested in climbing mountains might use this route to access the higher peaks.

Continuing south past Grant Village one eventually reaches the West Thumb. The West Thumb is a second collapsed caldera from an eruption some 162,000 years ago. The West Thumb Geyser Basin marks a spot where faults in the crust allow hot water to reach the surface. At West Thumb is Fishing Cone, where early park tourists used to "cast, catch, and cook". Casting into the lake, a hungry cutthroat trout was easily caught and immediately dunked in the scalding water of Fishing Cone where the fish would be cooked and ready to eat. Today such a practice is prohibited.

From West Thumb the road heads south with one part of the road branching towards the South Entrance and the Tetons. The road passes Lewis Lake, named for Meriwether Lewis of the Lewis and Clark Expedition. The expedition never entered Yellowstone Park, but one of its members, John Colter, left the expedition on its return journey back to St. Louis, Missouri, to trap beaver in Montana and Wyoming. On a 500-mile winter snowshoe trip, he crossed what is now Yellowstone and became the first white person to explore the park. The Snake River, largest tributary to the Columbia River, flows right past the South entrance station.

Those not heading to the Tetons will probably continue on the loop road to the Upper Geyser Basin. You cross the Continental Divide here—twice—and eventually reach one of Yellowstone's most famous icons—Old Faithful Geyser. Old Faithful got its name because of its fairly predictable eruptions. It does not erupt on the hour as common myth suggests, but rather spouts at between 30 and 90 minute intervals. There are many other geysers in the Upper Basin; indeed, more than a fifth of the world's geysers are found in this one small area.

Continuing past Old Faithful the loop road follows the Firehole River, one of two tributaries of the Madison River. The Firehole was originally named for all the burnt timber left by forest fires around the time the first trappers were exploring the area. Much of this country was burnt in the 1988 fires, so the river's name still applies. Numerous hot springs and other features are also common along the Firehole River's length.

At Madison Junction, one road heads west along the Madison River to the West Entrance at West Yellowstone. The Madison is a world-famous trout fishery and also a great place to see trumpeter swan, bison, and elk. The loop road continues north along the Madison's other tributary, the Gibbon River. Along the way spectacular Gibbon Falls is passed. Gibbon Falls, like most falls in Yellowstone, passes over a particularly hard rock rib that resists erosion, hence creating the falls.

Several large meadows found along the Gibbon River are well known for elk, including the aptly named Elk Park. This is a particularly good place to spot elk in the autumn when the bulls are

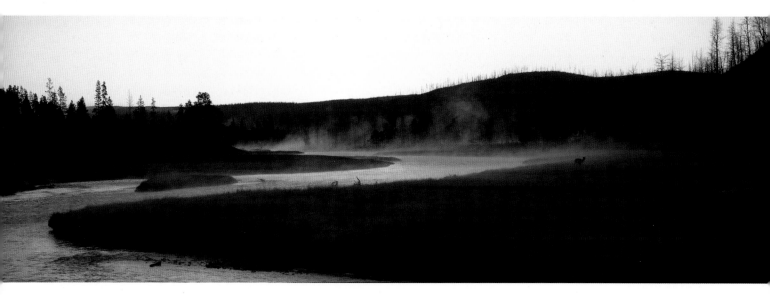

bugling and putting together harems. There are also a number of small thermal features along this stretch of road, including Fountain Paint Pots, where colorful muds bubble and boil. Eventually the loop road reaches Norris Geyser Basin and the end of the loop road.

## GEOLOGY

Part of Yellowstone's magic has of course to do with its thermal features. The heat source for the park's geysers and thousands of other thermal phenomena, including mud springs, fumaroles, and hot springs, comes from a giant "hot spot" or plume of molten magma that lies under the park. Cracks in the Earth's crust permit this heated rock to move closer to the surface, creating concentrations of thermal features. A few of the better-known areas include Norris Geyser Basin; Upper, Midway, and Lower Geyser Basins; and the West Thumb area. Mammoth Hot Springs near the Park's northern entrance is another thermal-rich region, but not over the hot spot.

The same magma that heats the thermal features is responsible for the region's seismic activity. The great 1959 earthquake near West Yellowstone, Montana, released the energy contained in 200 Hiroshima bombs. Earthquakes regularly roil Yellowstone, making it among the most seismically active places on Earth. At a more localized level among the many geyser basins, the very earth beneath your feet seems to rumble. Vast Yellowstone Lake is gradually being tipped up on edge by rising plumes of molten rock, so that today the northern shore is slightly higher than the south shore.

The oldest rocks in North America approach 4 billion years in age. The most ancient exposed rocks in Yellowstone are 2.7 billion years old. These rocks, granites and gneisses, formed deep in the earth and were pushed to the surface by tectonic forces and exposed when erosion stripped away overlying rocks. These ancient rocks can be seen in the Northeast corner of the Park

along the Lamar River and Slough Creek areas.

While these ancient gneisses and granites no doubt extend under most of the park, they are hidden by more recent volcanic and sedimentary rocks. In particular, the Absaroka Range along the Park's eastern border consists of lava flows and debris from volcanoes that erupted some 50 million years ago. The road from Cooke City by the Northeast Entrance and Sylvan Pass on the road from Cody through the East Entrance passes through fine examples of this volcanic rock. The repeated eruptions of these volcanoes buried many forests in lava and ash, creating the petrified trees that are common in some parts of the park, in particular on Specimen Ridge.

Ice Age glaciation put the finishing touches on the Yellowstone landscape. Much of the park was completely covered by an ice cap with glaciers flowing off the high country down various river valleys like the Madison and the Yellowstone. Many relics of this ice grinding still remain from the numerous small lakes that were gorged out by the ice rivers to the hummocky moraine visible near Slough Creek and Junction Butte in the northeast corner.

## HISTORY

Some have speculated that Native Americans avoided Yellowstone as a place of evil spirits. We will never know for certain what they thought about Yellowstone, but we do know that many tribes, including the Nez Perce, Blackfoot, Crow, Bannock, and others, frequently visited what is now Yellowstone

Park on hunting trips or when traveling from one area to another. One group, the Sheepeater Indians, lived in the park region hunting bighorn sheep, hence their name. For the most part we have to speculate about how they felt since there are no written records; however, it is difficult to believe that all these people didn't feel some kind reverence for the place—Yellowstone's magic transcends all cultures.

What we do know is that from the time of its first visit by white American settlers, the land that would someday become Yellowstone National Park was perceived as a special, magical place. Legendary fur trappers like John Colter, Jim Bridger, Thomas Fitzpatrick, Joe Meek, and Osborne Russell, who crossed the region in the early 1820s and 1830s, found the landscape so extraordinary that they told tall tales about the place because no one would believe the truth. John Colter, originally a member of the Lewis and Clark Expedition, was the first white man to traverse the land that would later be designated Yellowstone National Park. In 1807 he snowshoed across the park and came back describing boiling caldrons and sprouting jets of water. Later explorers dubbed the place "Colter's Hell."

Other fur trappers followed Colter, including the famous mountain man Jim Bridger, for whom the Bridger Teton National Forest to Yellowstone's south is named. Bridger told stories about petrified birds singing petrified songs on petrified trees and he suggested that the reason the Firehole River ran warm throughout the year was because friction caused it to heat up and give off steam. Osborn Russell, another trapper, made five trips in the 1830s through the region that would soon be designated

*The Central Plateau, seen in this view, fills the caldera of the old Yellowstone volcano which exploded some 600,000 years ago.*

Yellowstone National Park and, recognizing the superb beauty of the region, wrote "for my own part I almost wished I could spend the remainder of my days in a place like this where happiness and contentment seemed to reign in wild romantic splendor."

In the early 1870s, several military expeditions—including the 1870 Washburn Expedition (Mount Washburn is named after Henry Washburn, expedition leader) and the 1871 Hayden Expedition (Hayden Valley is named for the expedition leader, Ferdinand Hayden)—explored Yellowstone. They were so impressed with what they found that some expedition members began to lobby Congress to protect the region from commercial development. Very quickly Congress acted and in 1872 designated Yellowstone as the first national park in the world.

Then, as is often the case today, local and regional interests opposed park establishment. *The Helena Gazette* (Montana) wrote "We regard the passage of the act as a great blow struck at the prosperity of the towns of Bozeman and Virgina City." Some members of Congress lamented closing the region to development including logging, dam building, mining, and railroad construction. As one Congressman opined, he could "not understand the sentiment which favors the retention of a few buffaloes to the development of mining interests

amounting to millions of dollars." In 1892 a bill was introduced to Congress to abolish the park. Fortunately this and other efforts to reduce the protection of Yellowstone, or eliminate the park altogether, failed.

When first established there was no national park service to manage and watch over the park. One superintendent was appointed to administer the park, but he had neither staff nor any real legal power. Without any control, poachers regularly slaughtered the wildlife and curiosity seekers broke off pieces of thermal features and petrified trees. Finally in 1886 the U.S. Army was given the unusual task of patrolling the park to fend off poachers and to develop visitor access. The historic buildings at Mammoth Hot Springs are the remains of old Fort Yellowstone. The Army remained in charge of the park until 1918 when the National Park Service, which was founded in 1916, officially took over responsibility for administrating the nation's first park.

There were several controversies over the years, including the never-ending debates about whether the elk herds were too large or too small. At one point park rangers shot elk to reduce their numbers. In the 1960s an august panel of biologists, the Leopold Commission chaired by Starker Leopold (son of the famous ecologist Aldo Leopold), recommended a change towards a less interventionist approach. The committee recommended that natural processes be permitted to operate with a minimum of human interference. This alteration in policy resulted in real and controversial changes.

In the early 1970s the NPS decided to wean grizzly bears off garbage dumps, which had been used as feeding stations for the bears for decades. Many feared the bears could not cope with the loss of this important food resource and would disappear from Yellowstone. Fortunately the most pessimistic predictions were not realized and the bear numbers have increased in recent years.

Ironically, one of the reasons the bears have done well is the great abundance of elk, which provides a ready source of protein. Yellowstone grizzlies eat a higher percentage of meat than any other grizzlies found in North America. Another apparently risky decision was taken in 1995. Wolves were reintroduced into the park. The park now hosts between 100–200 wolves and today wolf-watching is one of the most popular wildlife activities in the park.

About the same time as the garbage dumps were being closed, the park began to allow natural fires to burn without immediate suppression. The great 1988 fires created more than 700,000 acres of new forest and wildlife habitat, demonstrating how much Yellowstone is still under the forces of natural processes rather than human dictates. In a sense, a person visiting Yellowstone is visiting the very fountainhead

for creation. It is one of the most intact natural ecosystems left in the temperate reaches of the world.

The park has been expanded several times, including an addition near Gardiner in the 1930s. Most of the park is surrounded by other public lands, primarily national forests. Indeed, the first national forest in the country, the Yellowstone National Park Timber Reserve, was created in 1891 along Yellowstone's eastern border, and the Teton Forest Reserve was established in 1897 along Yellowstone's southern border. There is growing recognition that management of Yellowstone and its special attributes, including thermal features and wildlife, requires thinking beyond the park's limited boundaries if we want to preserve migrating wildlife that wander both in and out of the park, or protect the geological wonders whose below-ground "plumbing" extends well beyond the park's borders. Today managers consider Yellowstone to be part of the larger Greater Yellowstone Ecosystem, with the park at its core.

Yellowstone has figured prominently in the development of global ideas about conservation. It is among the most spectacular landscapes found anywhere, graced with dazzling geysers, spectacular waterfalls, jagged peaks, impressive canyons, translucent lakes, and flowery meadows. Though originally set aside to protect its geological "wonders," today it is more widely known as a wildlife extravaganza where bighorn sheep, elk, bison, wolf, and grizzly roam unfettered. And it is a land still in transition, actively being created and recreated. Yellowstone is for many people the closest they will ever come to creation itself. This is not just figurative, but reality. Yellowstone is a living landscape geologically and biologically.

Yellowstone also has symbolic value. The park has been at the center of society's shifting values and ideas about the philosophical, spiritual, and functional human relationship to Nature. The setting aside of Yellowstone from commercial development as a public park in 1872 signaled a big change in U.S. policy. For a hundred years it had been the policy of the government to assist and promote development and resource exploitation. With the designation of Yellowstone, a line was drawn in the sand that said at least in a few special places this was no longer going to be true. Yellowstone was also the last place for wild bison left in the West. The park was critical to saving wild bison and represents the first successful effort to save a species from extinction. Finally, the Yellowstone philosophy of minimum human intervention in natural processes has its own symbolic worth. While no place is completely beyond the reach of human control, Yellowstone represents one of the last places on Earth where nature, rather than humans, is the dominant influence upon the land. The park represents a precious (and rare) kind of humility.

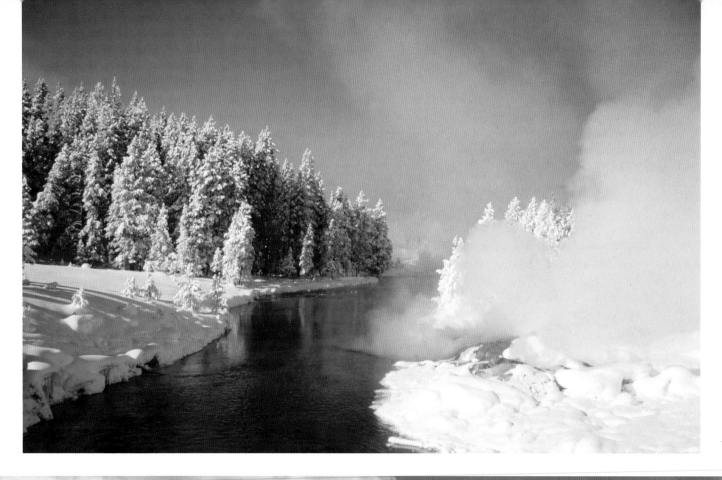
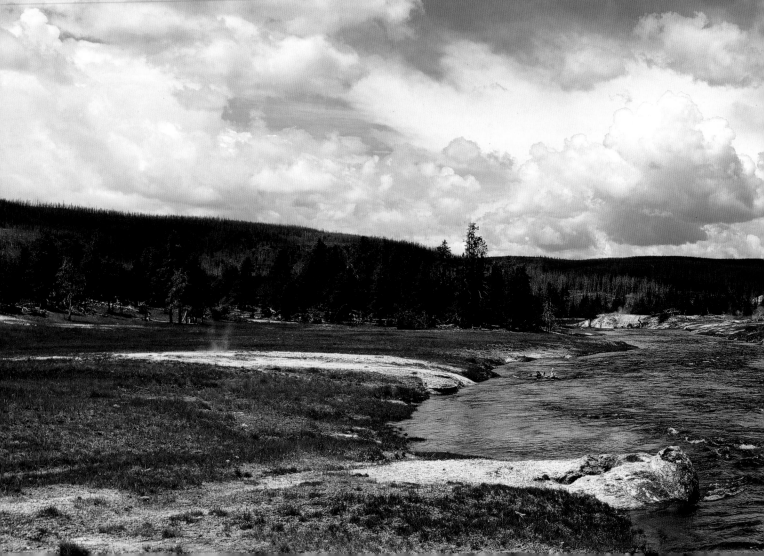

## FIREHOLE RIVER IN WINTER

*The Firehole River's thirty-mile long course runs through the Upper, Midway, and Lower Geyser Basins. It is a mecca for fly fishermen, but Firehole, along with the Madison and Gibbon Rivers, was temporarily closed to fishing in July 2003. The closures were implemented because of unusually high water temperatures caused by thermal run-off and unprecedented warm temperatures in the region. At the time of the closure, water temperatures were measuring in the mid- to upper 70s which can be lethal to the native trout population. However, the rivers only remained closed for a few months; the Madison and Gibbon Rivers reopened to fishing in August and Firehole was reopened in September that year.*

## FIREHOLE RIVER

*Despite the fact that the Firehole flows through several major geyser basins with numerous hot springs and geysers feeding into it, the river's name is attributed to mountain men who referred to the burnt timber found along the banks of the river, which were the result of numerous fires.*

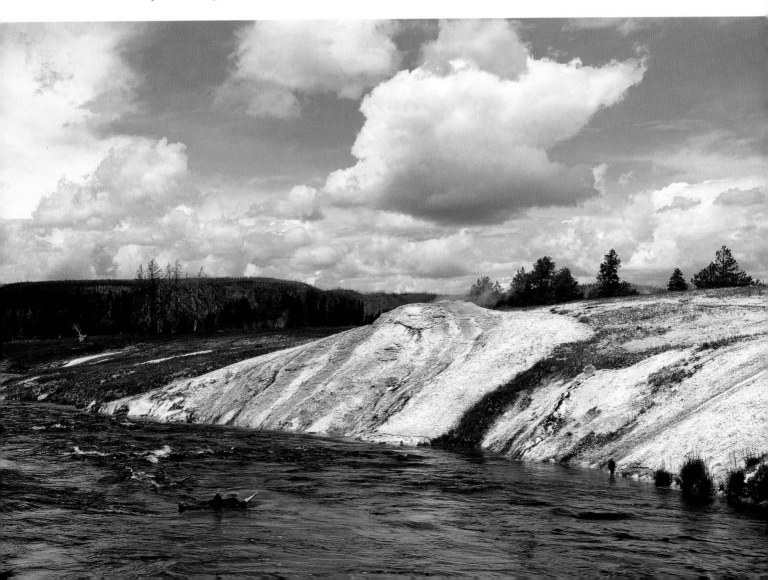

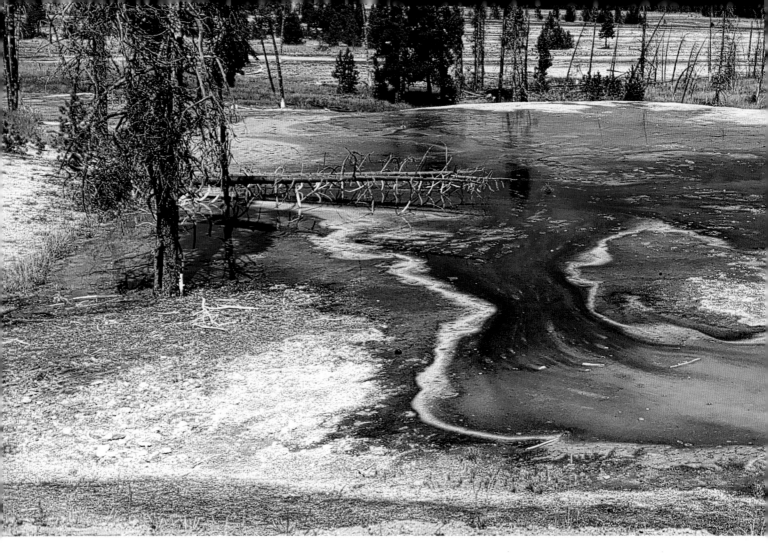

Above

## FIREHOLE SPRING, LOWER GEYSER BASIN

*Early explorers thought this spring, originally named Beauty Spring, was one of the major attractions of the Lower Geyser Basin. It was renamed Firehole Spring for the gaseous bubbles that give the pool a flickering effect like flames in a fire.*

Right

## FIREHOLE RIVER AT SUNSET

*The Firehole River combines with the Gibbon to make up the Madison, one of the headwaters of the Missouri River.*

Overleaf

## CLEPSYDRA GEYSER, LOWER GEYSER BASIN

*"Clepsydra" means "water clock" in Greek. Though its eruptions are more irregular today, when the first explorers were naming features in the park Clepsydra Geyser used to erupt approximately every three minutes.*

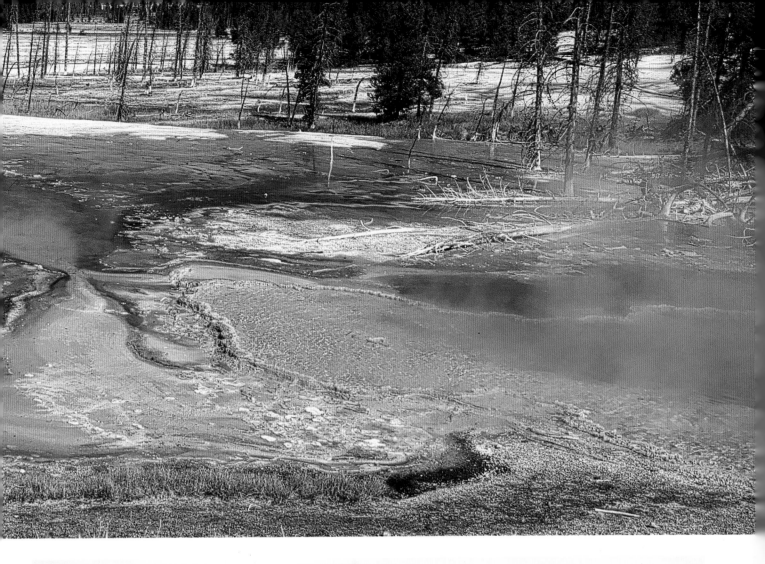

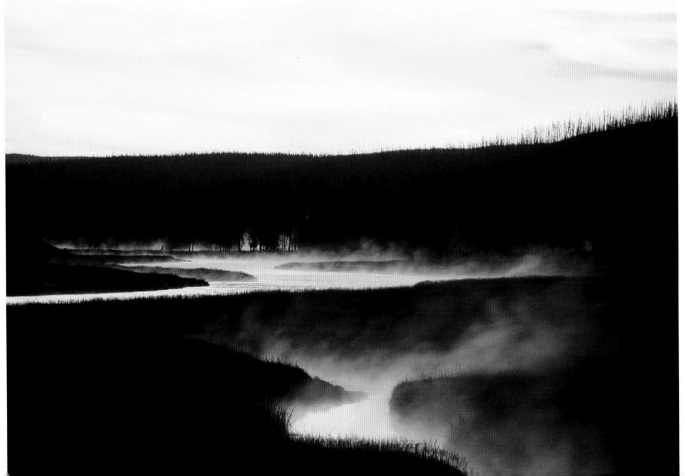

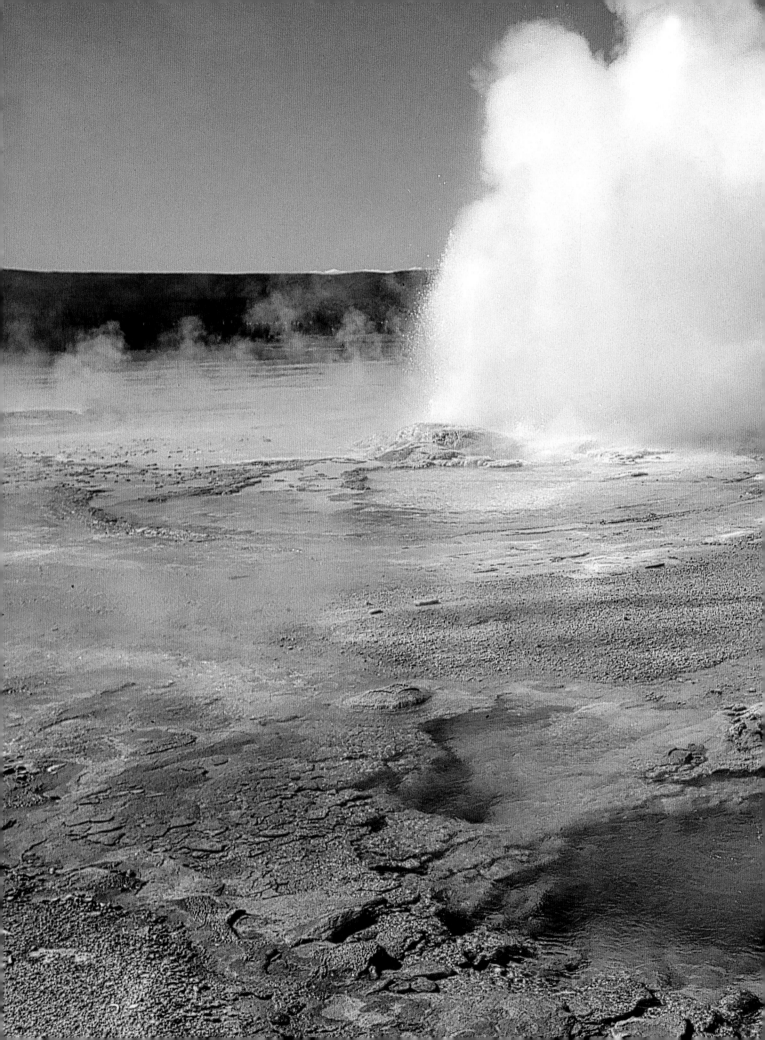

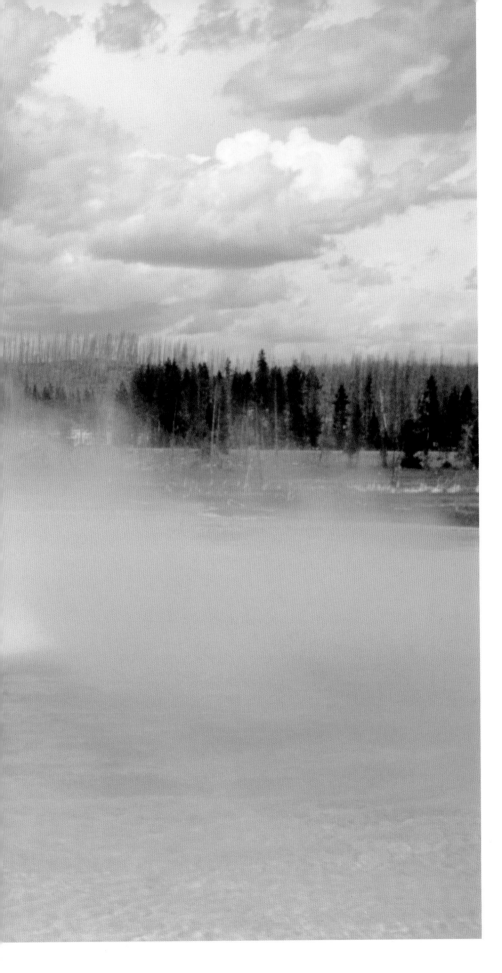

## SUNSET LAKE

*Located in the Black Sand Basin, Sunset Lake is a shallow thermal pool that flows into Iron Creek and Rainbow Pool. The beautiful blue waters at the center of this sinter-based pool blend into yellow and orange bacteria, with algae at its edges. Following the earthquake in 1959, much of the bacteria and algae in Sunset Lake's tributaries were destroyed. During its rare eruptions the pool surges to a maximum height of ten feet.*

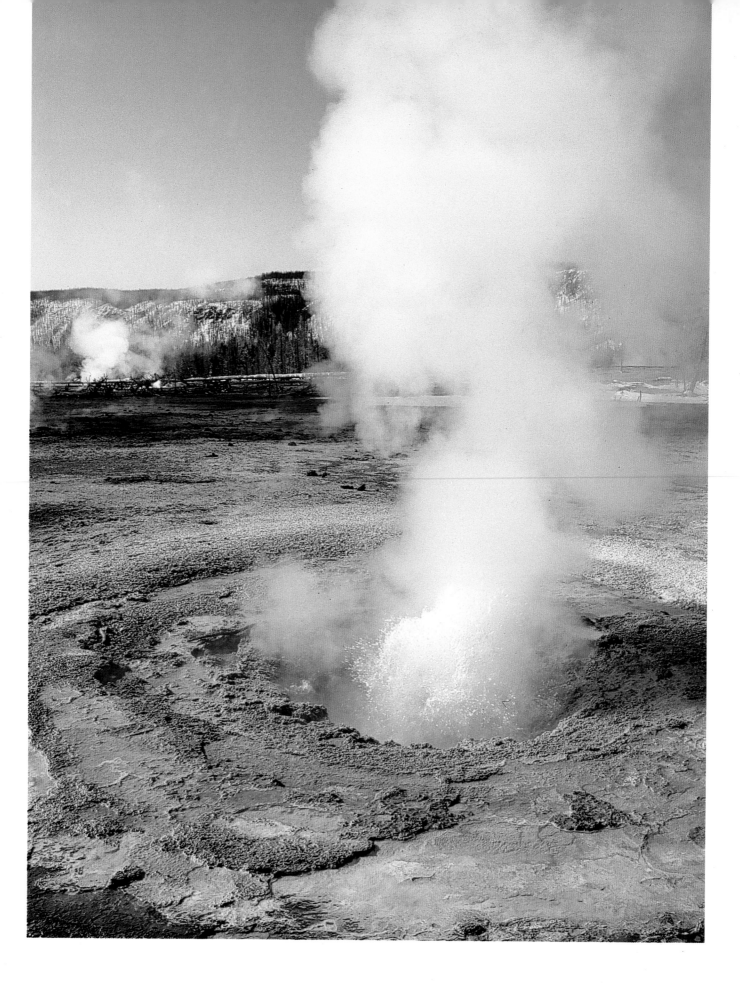

Left

## STEAM RISES FROM MUSTARD SPRING IN THE BISCUIT BASIN

*The temperature of this active pool registers between 172 and 198°F. Named after the mustard-colored lining of its crater, the spring has been known to erupt at intervals of 5 to 10 minutes and can reach heights of 4 to 6 feet.*

Below

## BEAUTY POOL

*Beauty Pool is in the Upper Geyser Basin, down the Firehole River from Old Faithful. The aptly named spring has a deep blue center, fading to yellow-orange along the margins.*

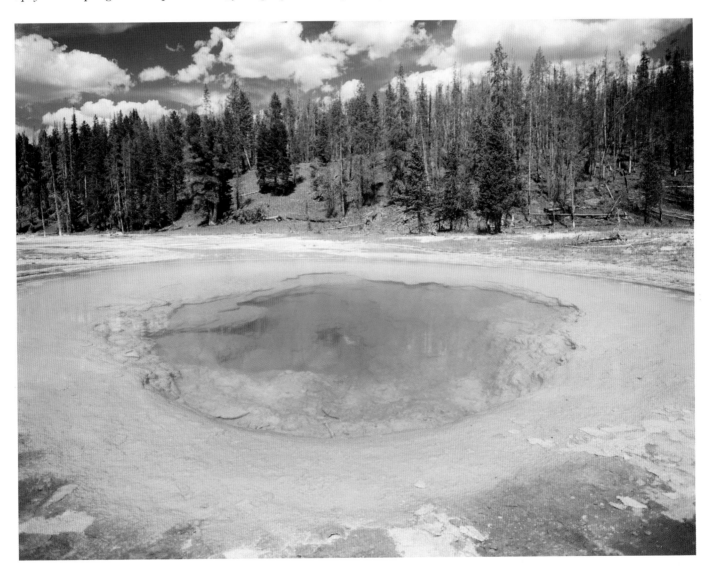

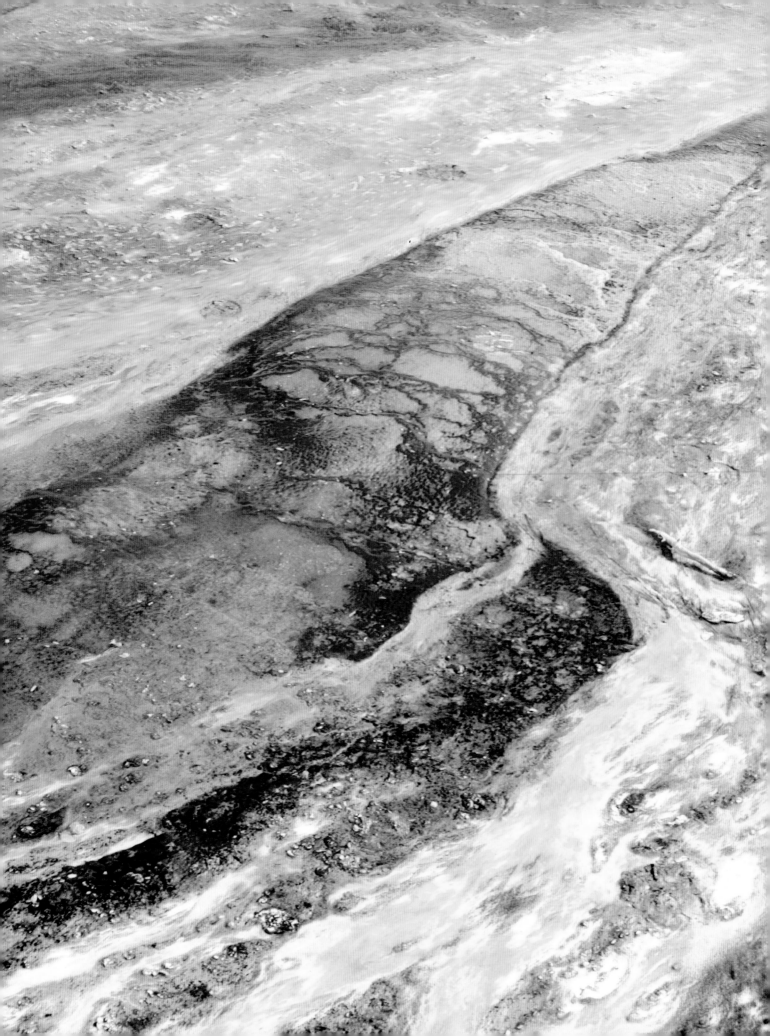

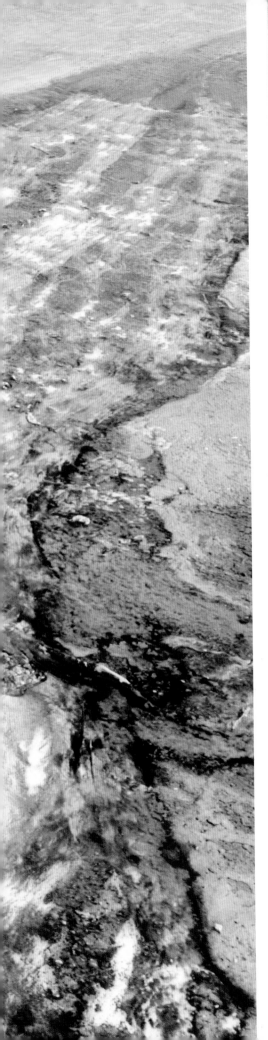

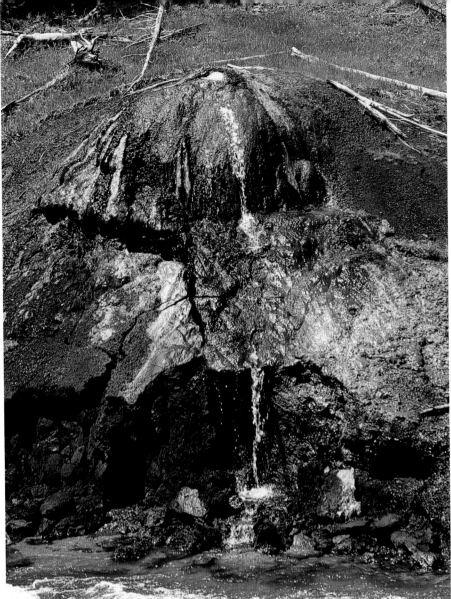

Above

## CHOCOLATE POTS ON THE GIBBON RIVER

*The Chocolate Pots are a collection of brown mounds on the east side of the Gibbon Basin. These hot springs have a tremendous amount of iron oxide in their water, hence the distinctive reddish-brown coloration.*

Left

## BLACK SAND BASIN

*Originally named the Emerald Group by A.C. Peale in 1878, tourists began to refer to the basin as Black Sand Basin as it is darkened by tiny pieces of black obsidian or volcanic glass. Black Sand Pool, within the basin, has an apparent connection to the distant Giant Geyser as two days before the eruption of Giant on September 7, 1978, the water of the pool turned murky gray.*

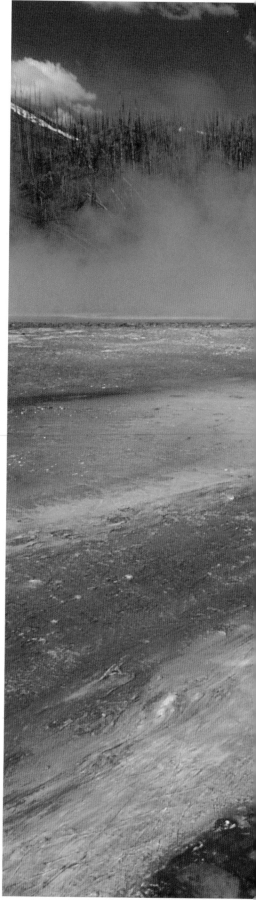

## GRAND PRISMATIC SPRING

*Grand Prismatic Spring is the largest hot spring in North America. It is almost 370 feet in diameter with a flow of 4,000 gallons of water per minute. In the center of the pool the water is 188°F—too hot to support life—but in the cooler water along the edges of the pool, colonies of thermophilic (heat-loving) cyano-bacteria and algae thrive. The wonderful spectrum of red, yellow, and orange colors along the spring's margin are created by these algae and bacteria. Grand Prismatic Spring is the premier thermal feature in the Midway Geyser Basin and the most spectacular.*

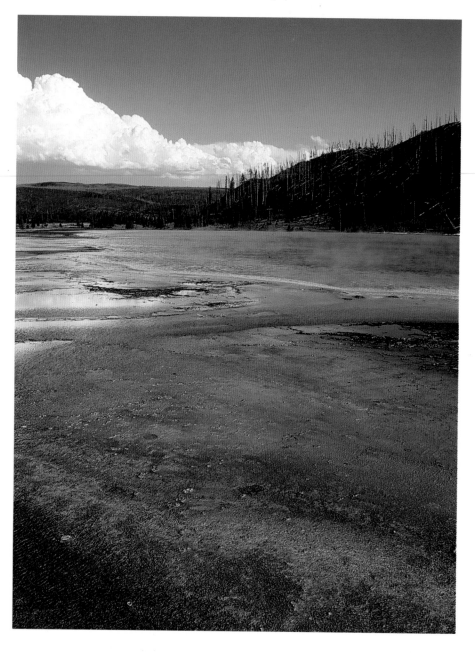

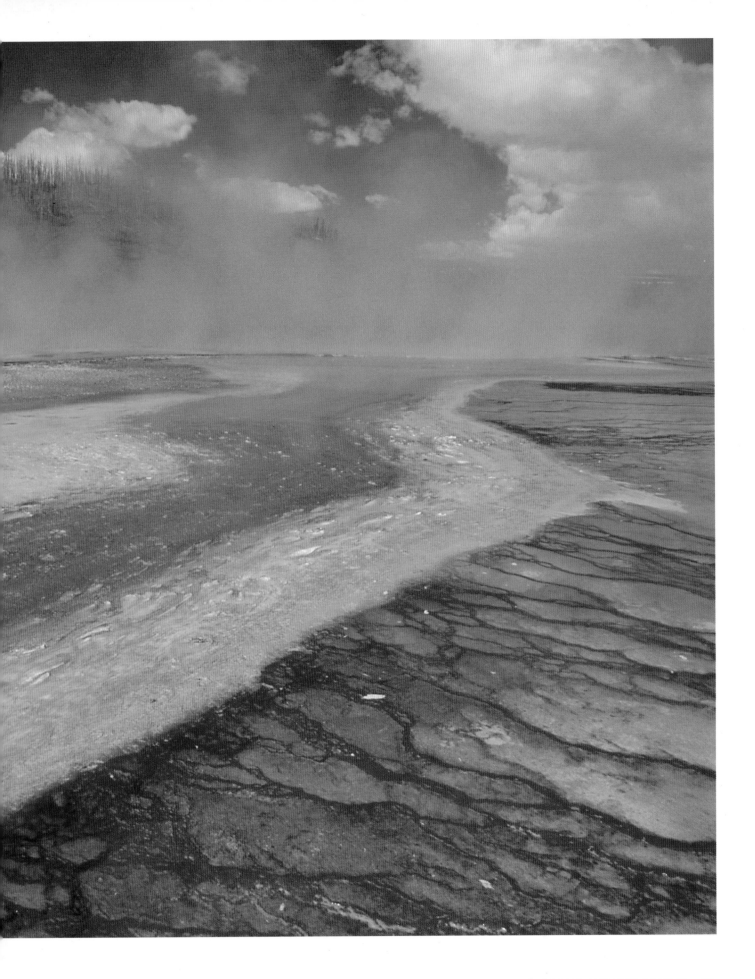

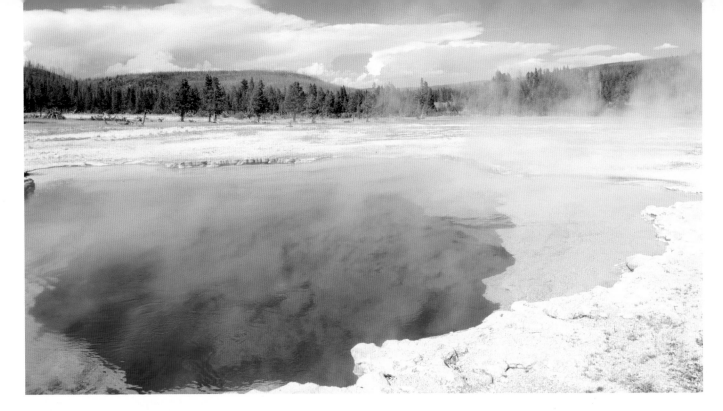

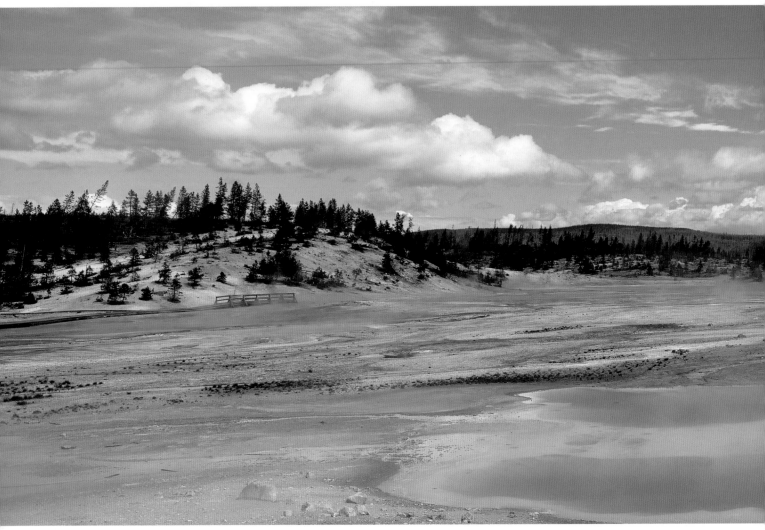

Left

## SAPPHIRE POOL AT BISCUIT BASIN

*Biscuit-like sinter deposits once lined the edge of Sapphire's crater, and in the 1880s it received its name for the knobby formations. Then, in 1959, during the Hebgen Lake Earthquake, the Sapphire Pool began to erupt, throwing up a jet of water reaching as high as 125 feet into the air, causing the biscuit-like formations to break away and dislodge. Eventually the eruptions subsided and now this beautifully bright blue pool is nearly silent; it has not erupted properly since 1974, except for a few surprise hiccups in 1991.*

Below

## PORCELAIN BASIN

*Located in the Norris Geyser Basin, Porcelain Basin is a stretch of open terrain comprising hundreds of geothermal features. Its combination of acidic and alkaline waters has created an environment that is hostile to most plant life. The thin surface of the basin has a pulsating, porcelain-colored crust, tinged yellow and orange by sulphur and iron oxides. New springs and other features are constantly forming due to hydrothermal explosions—some of the features are ephemeral while others have become permanent fixtures.*

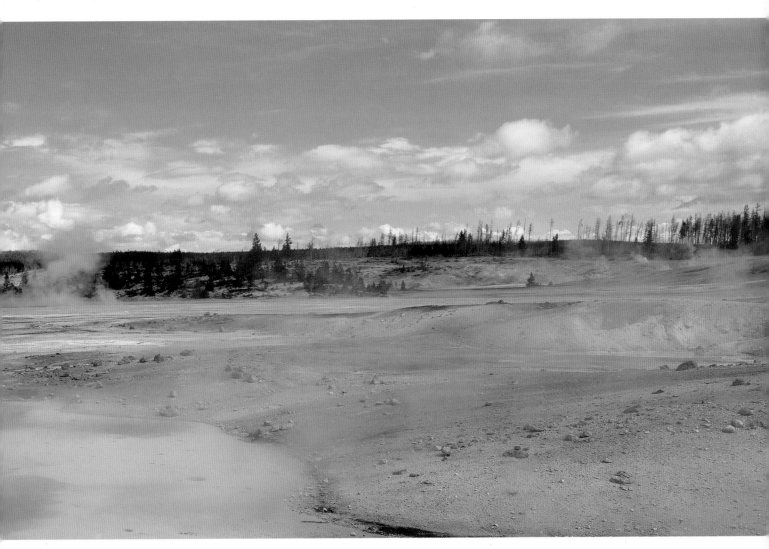

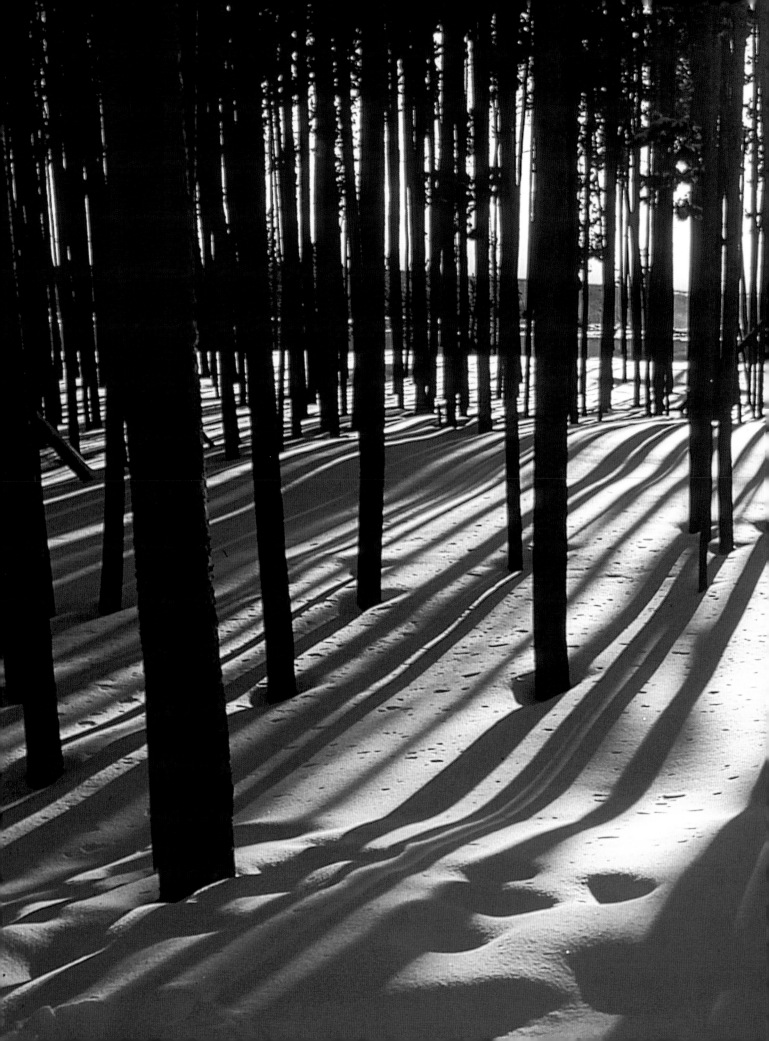

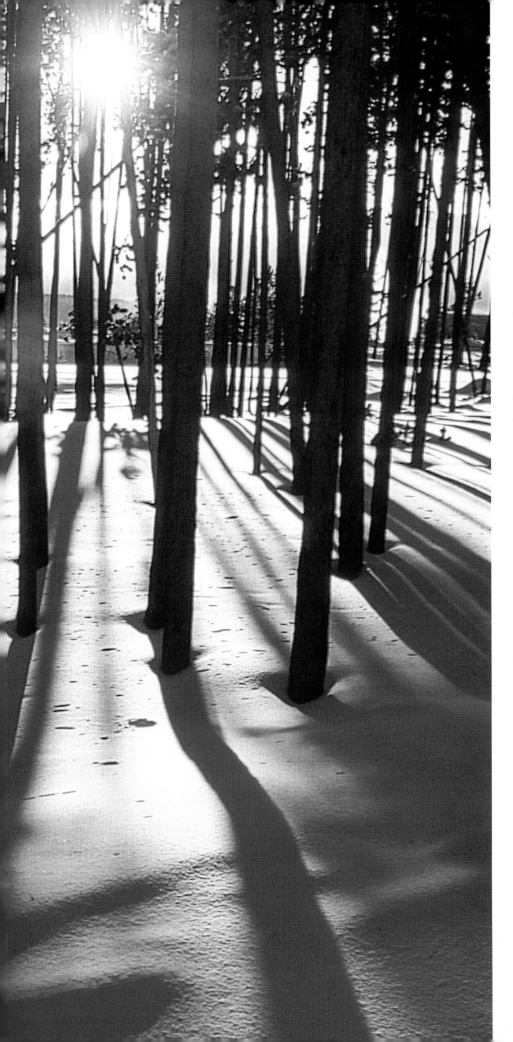

## NORRIS GEYSER BASIN

*Light diffuses through stands of lodgepole pine during a winter sunset at the basin, adjacent to the north rim of the Yellowstone caldera. Norris Geyser Basin is the hottest and most changeable thermal area within the park. It is the location of the tallest active geyser and hosts an impressive collection of colorful thermal hot springs, teaming with microscopic life. The basin is actually made up of two major areas: the Porcelain Basin and the Back Basin. Porcelain Basin is made up of open terrain littered with hundreds of densely packed geothermal features; in contrast, Back Basin offers a forested landscape and its features are more scattered and isolated.*

## GIBBON FALLS

*The falls were named for General John Gibbon, who chased the Nez Perce Indians on their famous 1,500-mile trek from Oregon to Canada in 1877, part of the tremendous journey through Yellowstone Park. The falls are 80 feet tall and are located approximately halfway between Madison Junction and the Norris Geyser Basin. Gibbon Falls marks the spot where the Gibbon River cascades over the edge of the Northern escarpment into the Yellowstone caldera. It is an extremely popular tourist attraction so it is far from a tranquil resting spot but well worth the attention.*

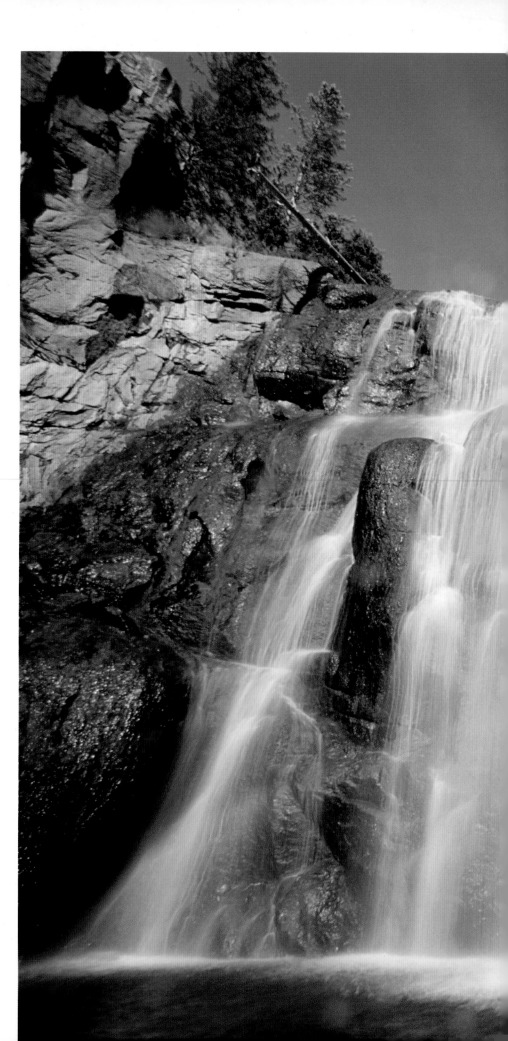

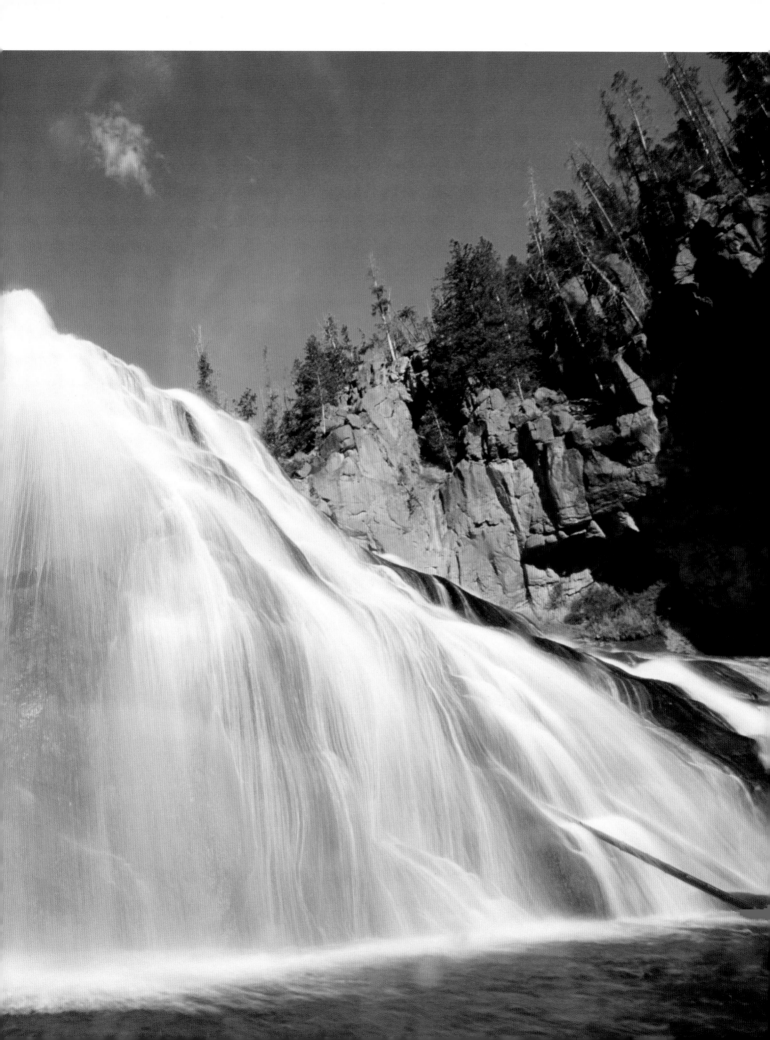

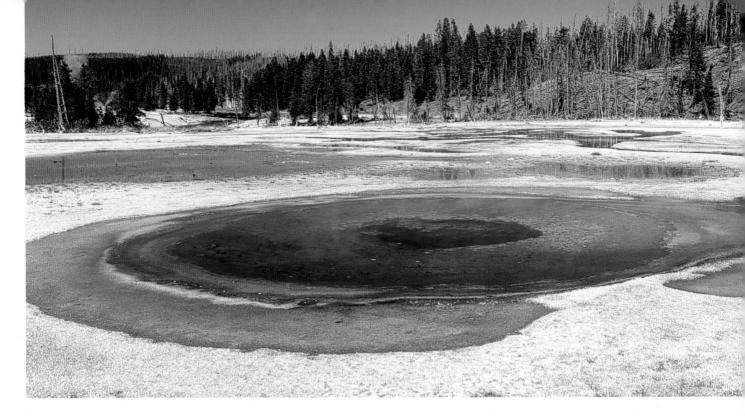

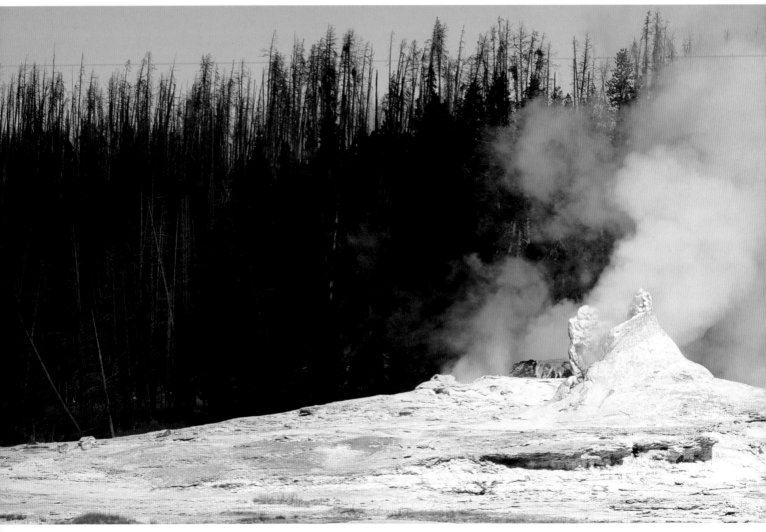

Left

## CHROMATIC POOL

*The deep blue color in the center of this pool is caused by the refraction of light in the deeper waters of the spring, much as light is refracted in the sky giving us its blue depths. In the shallower, cooler waters at the edge of the pool, a plethora of bacteria and algae thrive to produce a kaleidoscope of different pigments, which combine to create the beautiful yellow, red, or orange colors.*

Below

## GIANT GEYSER

*Giant Geyser is located in the Upper Geyser Basin near Old Faithful and is one of the most remarkable and powerful geysers, sending streams of water as high as 250 feet into the air. Unlike its close neighbor Old Faithful, whose eruptions last little more than a few minutes, a Giant Geyser eruption can last for 45 to 120 minutes. The Giant was dormant for a long period but it is now becoming more active. Its eruptions are erratic, but if you happen to catch one the display is spectacular.*

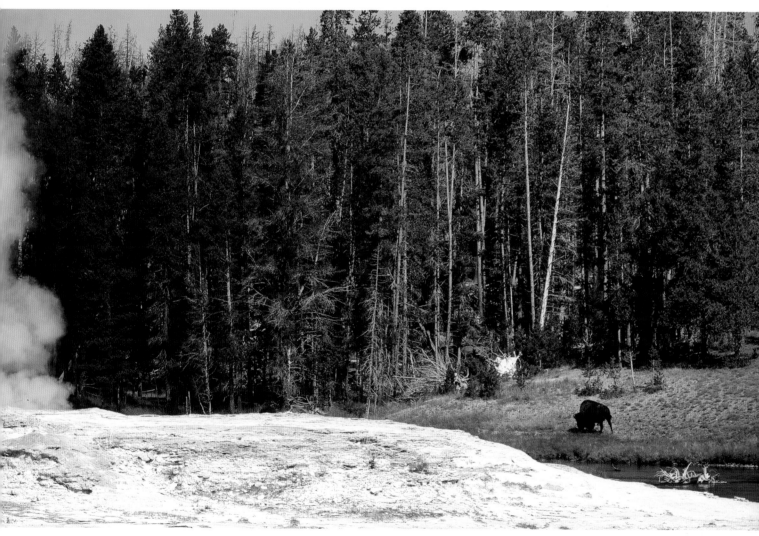

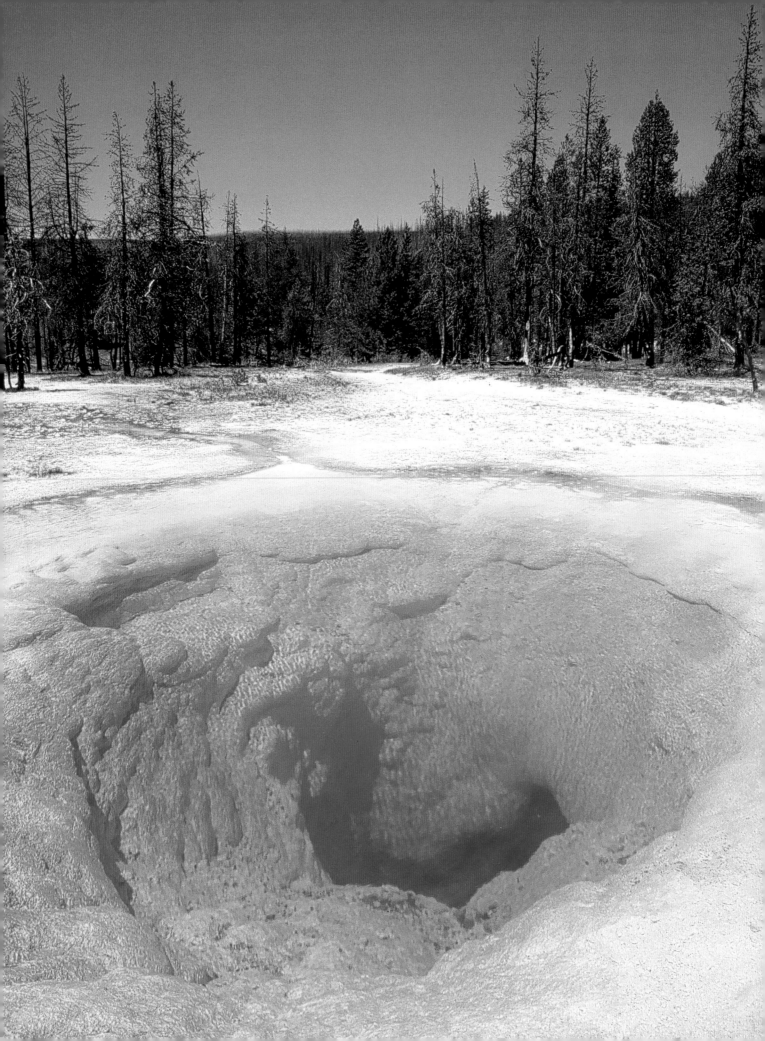

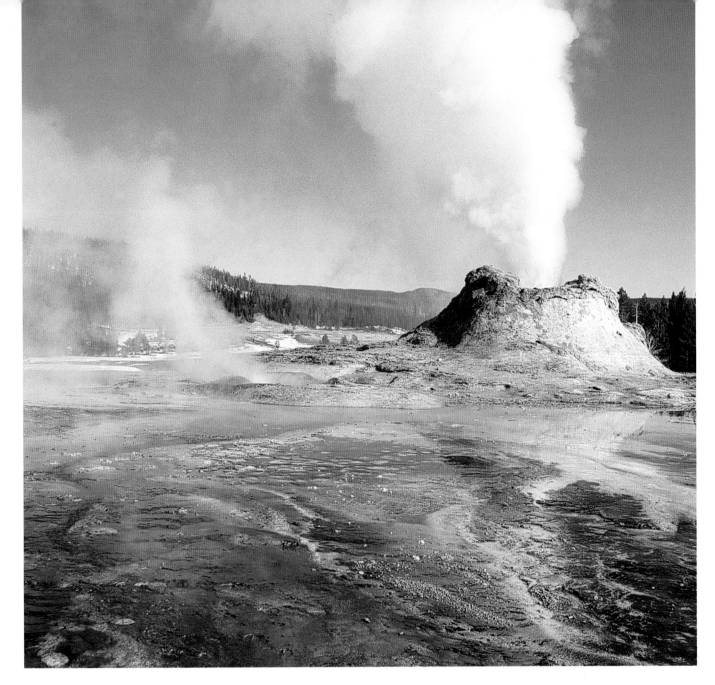

## CASTLE GEYSER

*Named for its supposed resemblance to a European castle, Castle Geyser spouts water as high as 100 feet. It erupts twice daily; each eruption lasts around twenty minutes and is followed by a forty minute steam phase. The cone was vandalized in the early years so its appearance has been altered from its original more castle-like silhouette.*

Left

## MORNING GLORY

*Morning Glory in the Upper Geyser Basin is a beautiful, deep blue pool, and one of Yellowstone's most popular thermal features. Its popularity, however, resulted in the accumulation of debris thrown in by early visitors. The build up of pennies, handkerchiefs and other objects reduced the flow of water and encouraged the growth of bacteria, visible in the pool's yellow- and orange-colored edge.*

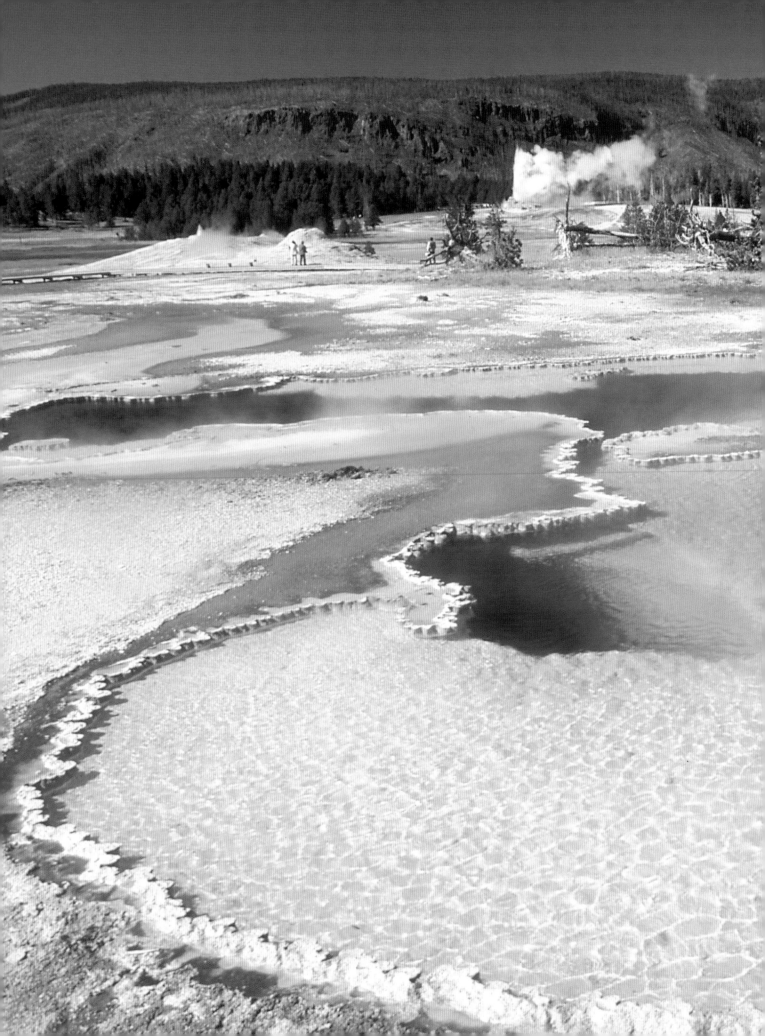

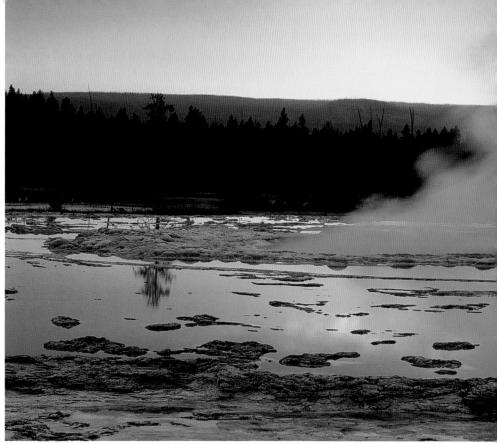

## GREAT FOUNTAIN GEYSER

*Located in the Firehold Lake Drive in the Lower Geyser Basin (about 9 miles north of Old Faithful), Great Fountain Geyser can spout water as high as 150 feet in the air, which makes it one of the highest-spouting active geysers in the world, though daily eruptions are more often in the 70- to 100-foot range. Eruptions generally occur every 12 hours or so and can last for up to an hour each time.*

Left

## DOUBLET POOL IN THE UPPER GEYSER BASIN

*Doublet's sinter edge extends over its surface, forming layered ledges on this sapphire-colored pool. Although it has experienced few eruptions, Doublet Pool is well known for its thumping sounds. The low, thudding sensation that can be felt when standing close by is most likely caused by gas and steam bubbles collapsing deep below the surface. Slight pulses on the water accompany the underground vibrations. If you look closely you can also see Castle Geyser venting in the background.*

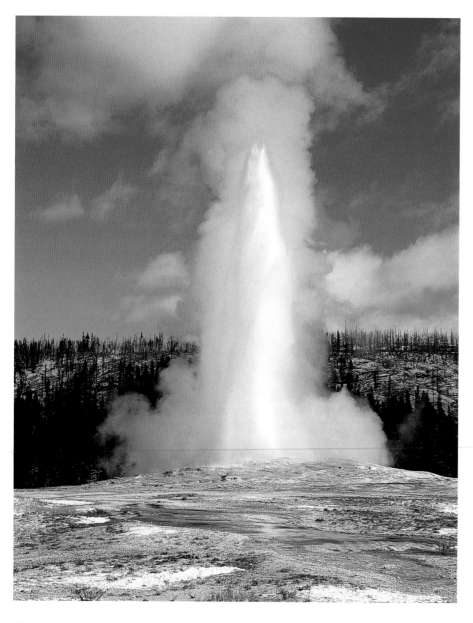

## OLD FAITHFUL

*Old Faithful, in the Upper Geyser Basin, was named by members of the 1870
Washburn Expedition. While the geyser still erupts regularly, the timing now varies
from 30 minutes to 120 minutes apart. Each eruption usually lasts for 1¹/₂ to 5 minutes
and can reach heights of 90 to 190 feet. In the last decade or so eruptions have become
less frequent.*

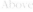

Right

## TRACKS ACROSS THE UPPER GEYSER BASIN

*A winter day near Old Faithful. A fifth of the world's geysers, including Old Faithful,
are found in the Upper Geyser Basin, which means the region has the highest
concentration of these amazing thermal features on Earth.*

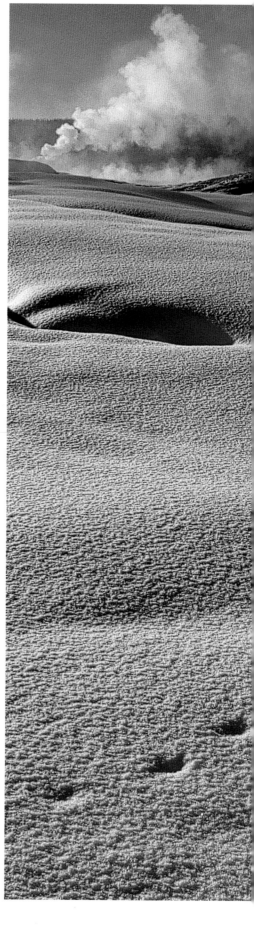

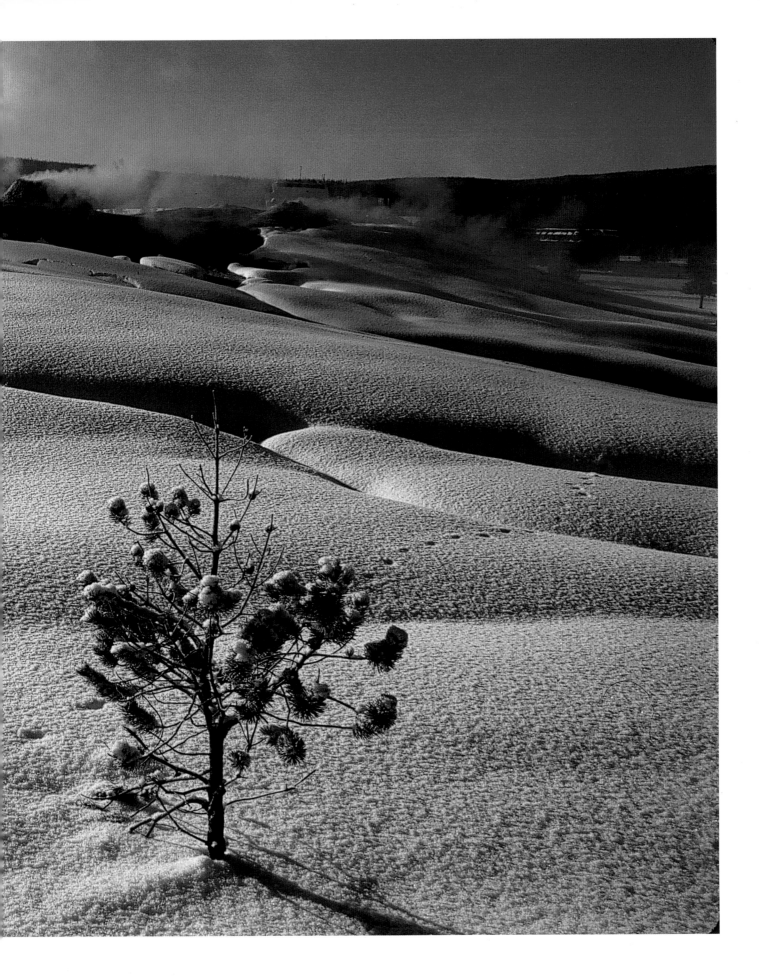

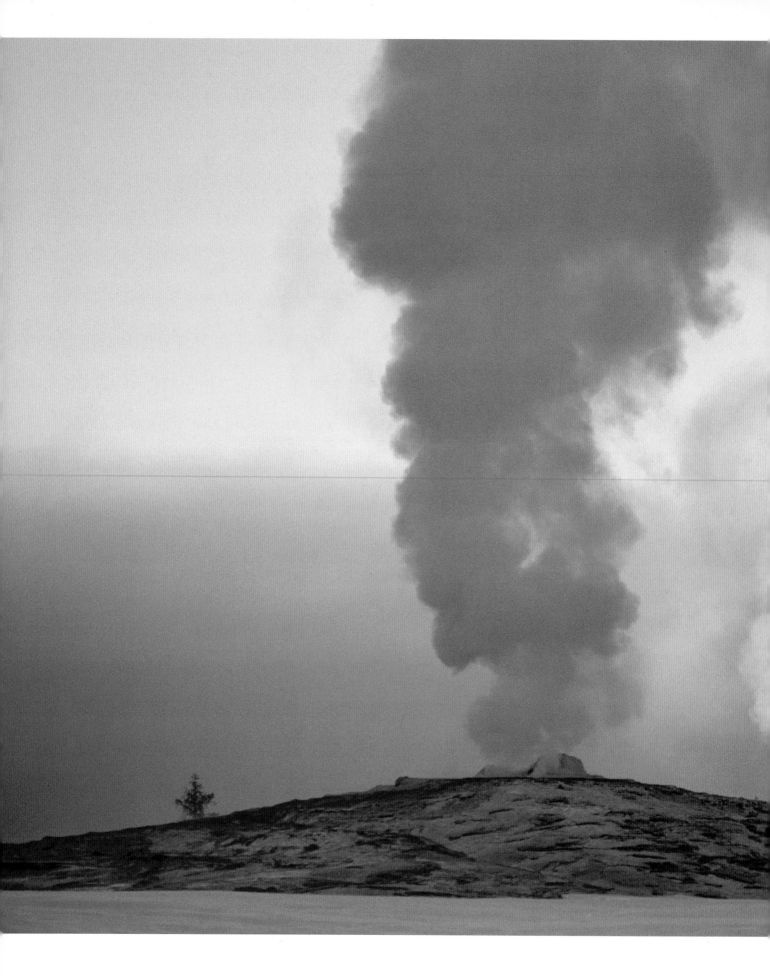

Left

## OLD FAITHFUL STEAMING

*There are two other geysers within Yellowstone that have the temerity to claim the same name, but this is the original. When first discovered the geyser was not the biggest in the park nor could it claim to have the most regular eruptions, but it was the biggest regular geyser and so impressed the Washburn expedition team that it earned the name from them. Old Faithful is deceptive in size as the benches situated around it are set over 300 feet back from the edge of the geyser and with no other features close by to provide perspective it is easy to misjudge  just how big it is. One of the best views of Old Faithful can be gained from the top of Geyser Hill, but be careful of the wind direction, otherwise all you may end up seeing is a cloud of steam!*

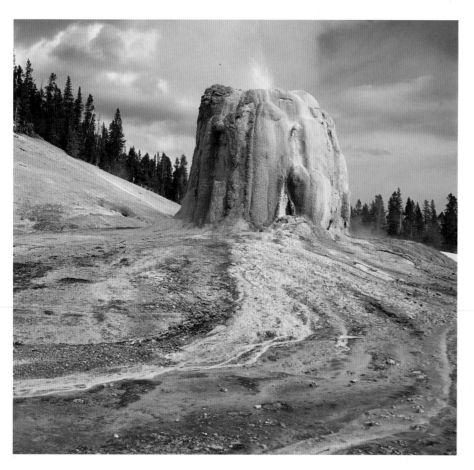

Above

## LONE STAR GEYSER

*Lone Star Geyser is a little way off from the other geysers in the Upper Basin, away from the well-trodden tourist track and accessible along a short trail. Eruptions are regular and occur approximately every three hours. Backcountry geysers such as Lone Star are well worth the visit due to their more natural and undisturbed environment.*

Right

## SNOW SCULPTURE

*Snow and wind create beautiful patterns on the side of the Grand Canyon of the Yellowstone. Winter is a superb time to view the thermal features of the park as there are far fewer tourists and many people who visit in the colder season come to view the vast array of wildlife that the park supports.*

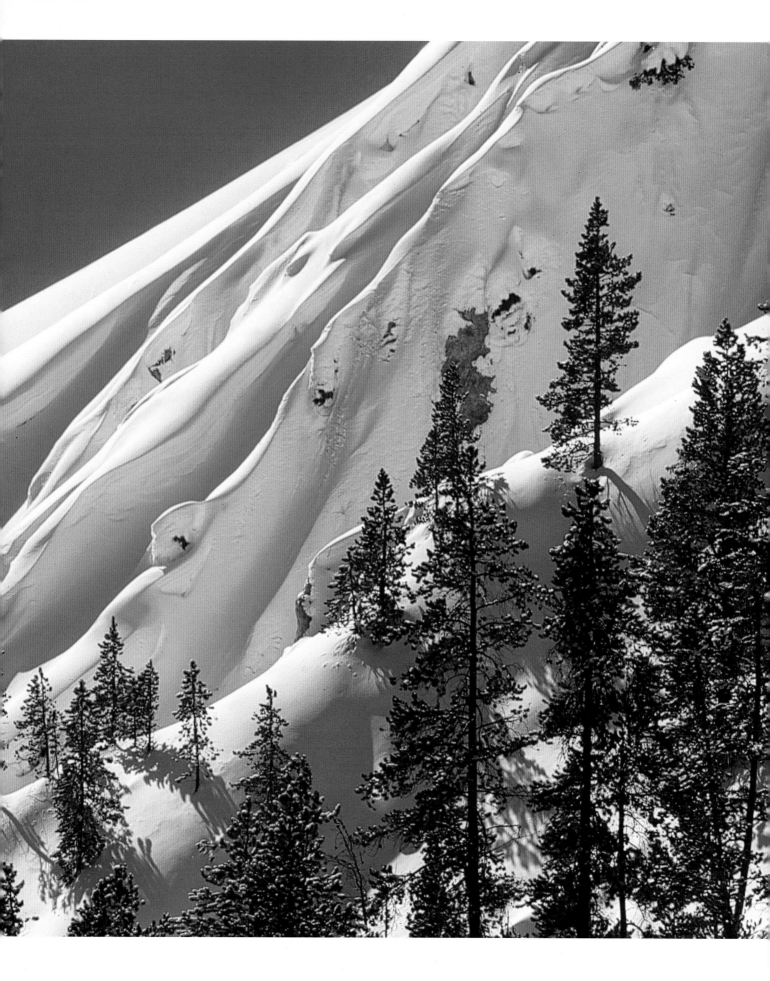

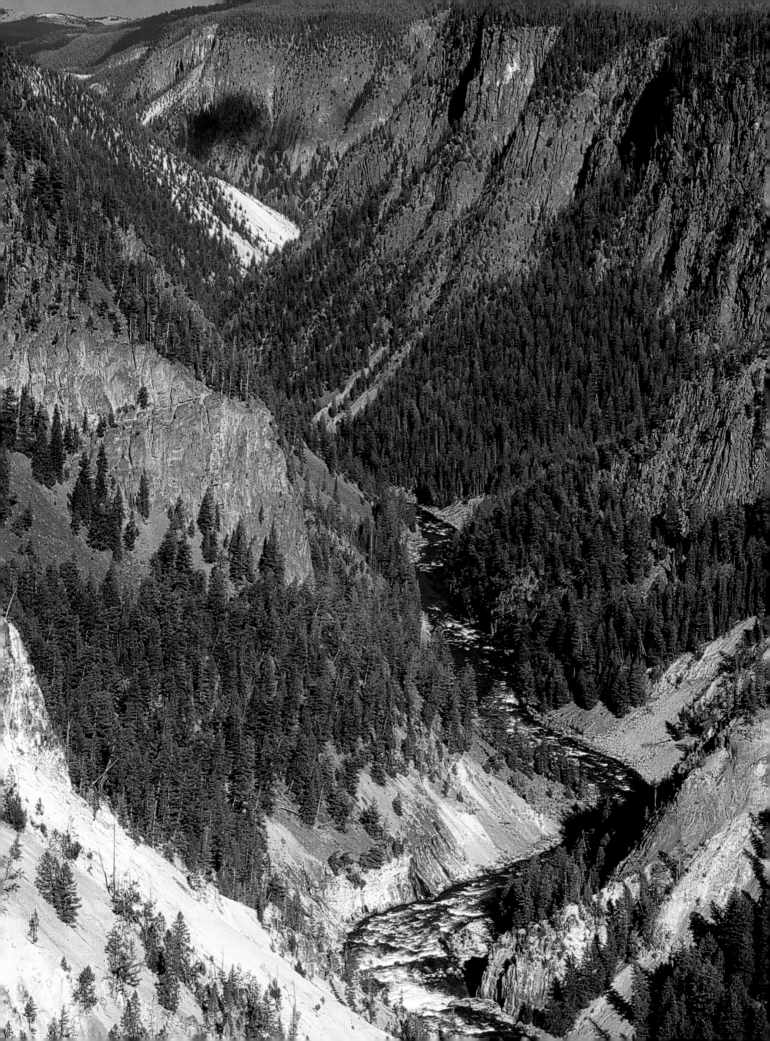

# GRAND CANYON

*The Yellowstone River has carved a deep canyon through the rhyolite rock (deposited by the laval flows during the caldera eruption some 600,000 years ago) that makes up the 20-mile long Grand Canyon. Hot springs are found along the length of the gorge. The canyon's distinctively beautiful yellow and red hues are actually formed by the thermally altered rock that has undergone chemical changes caused by the heated water. The rhyolite contains a variety of iron compounds and the variations in color indicate the presence or absence of water. As the rock is slowly exposed to the elements the iron compounds within it are oxidizing (rusting) and give rise to the spectacular colors of the canyon.*

# EROSION

*The rim of the Grand Canyon displays substantial erosion due to the area's geothermal activity. Because the rhyolite rock, of which the canyon is composed, has been thermally and chemically altered, it is consequently much softer and more susceptible to the effects of weathering and erosion.*

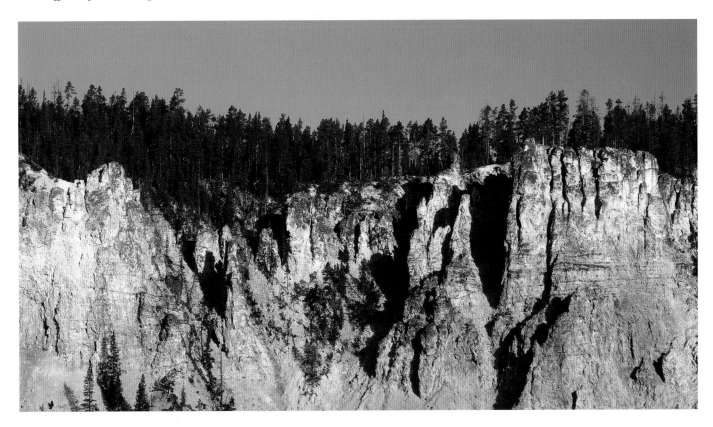

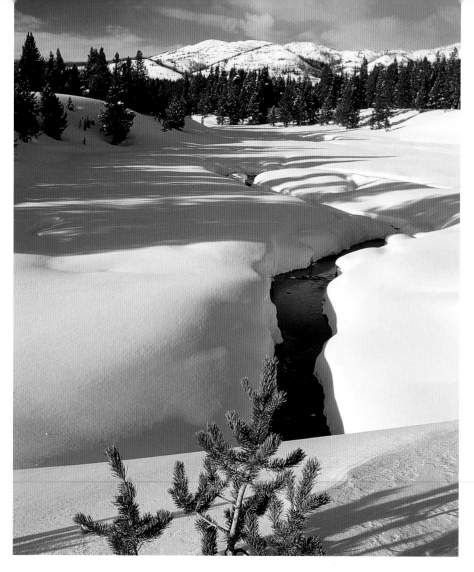

## CASCADE LAKE TRAIL

*A deep blanket of snow covers a meadow near the Cascade Lake Trail on the southern edge of the Dunraven Range. The trail provides a gentle three hour hike across meadows and small creeks and is the ideal trail for those visitors who want to experience the more remote and pristine areas of the park but are short of time.*

## LOWER FALLS

*The awe-inspiring Lower Falls plunges 308 feet into a canyon that is more than 1,000 feet deep. The falls are the tallest in Yellowstone.*

## HAYDEN VALLEY CLOUDSCAPE

*The Yellowstone River flows through the Hayden Valley, one of the best wildlife viewing areas in the park. Bison, along with grizzly bear, are often sighted in this region.*

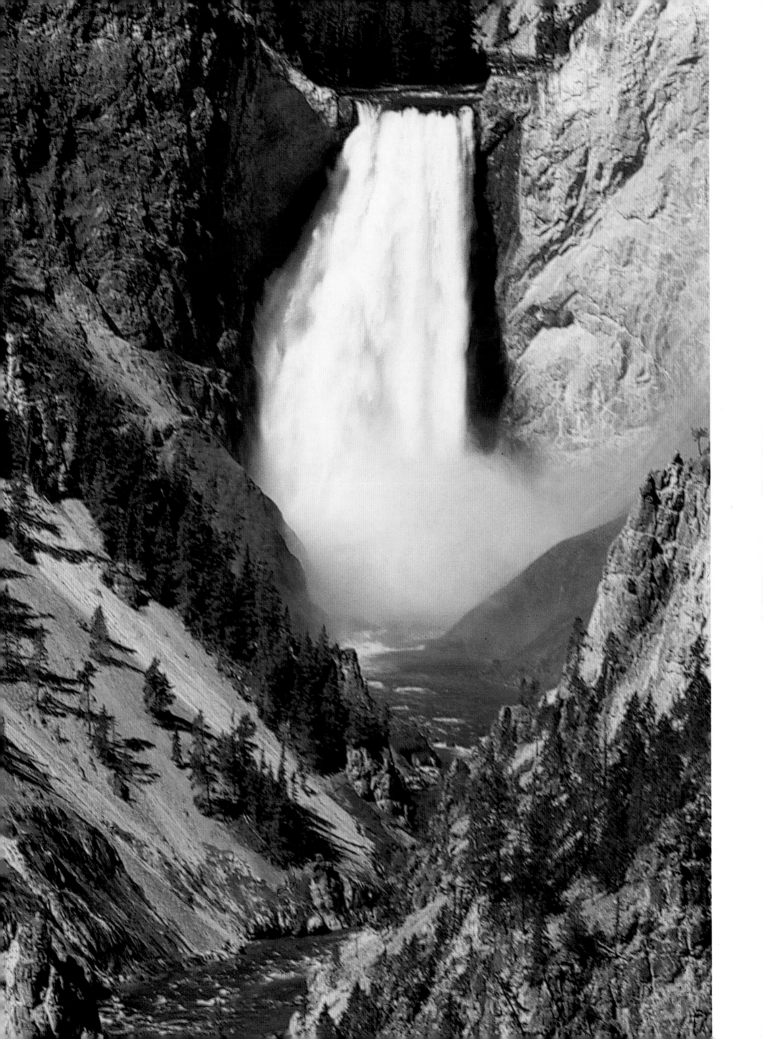

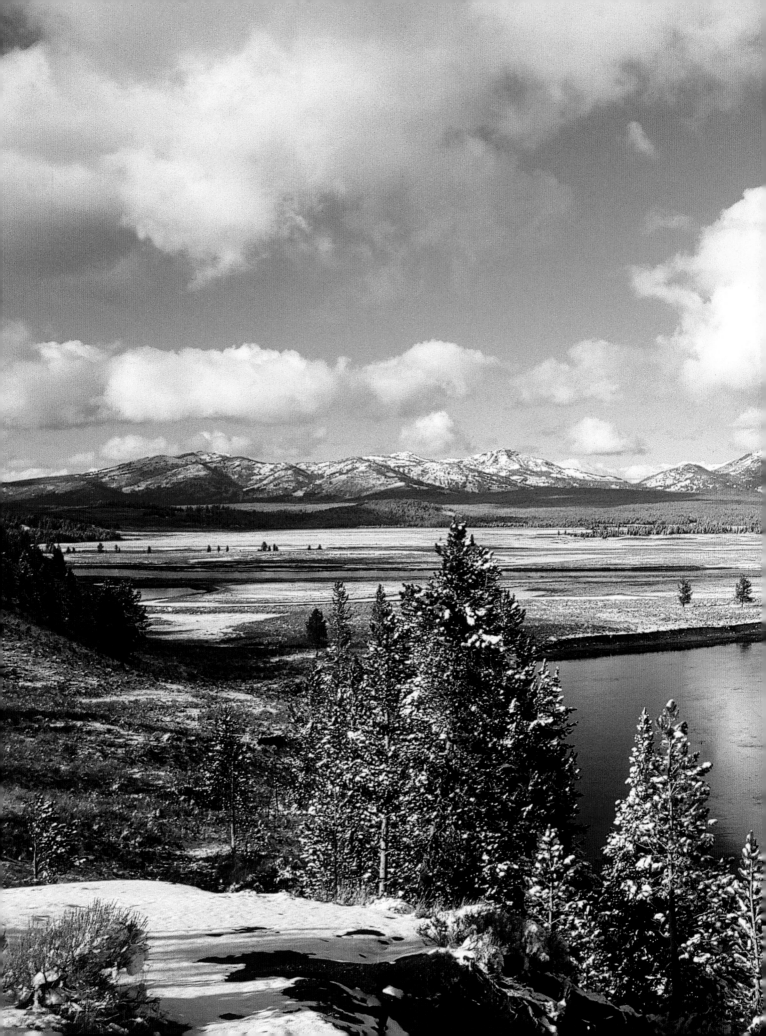

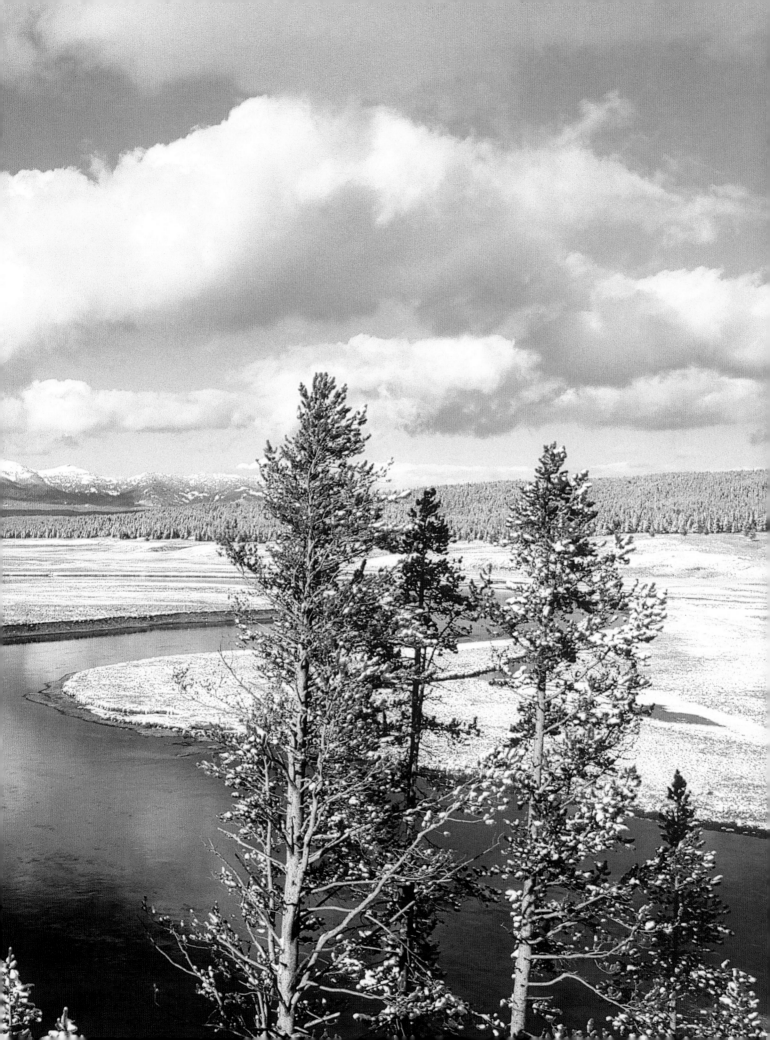

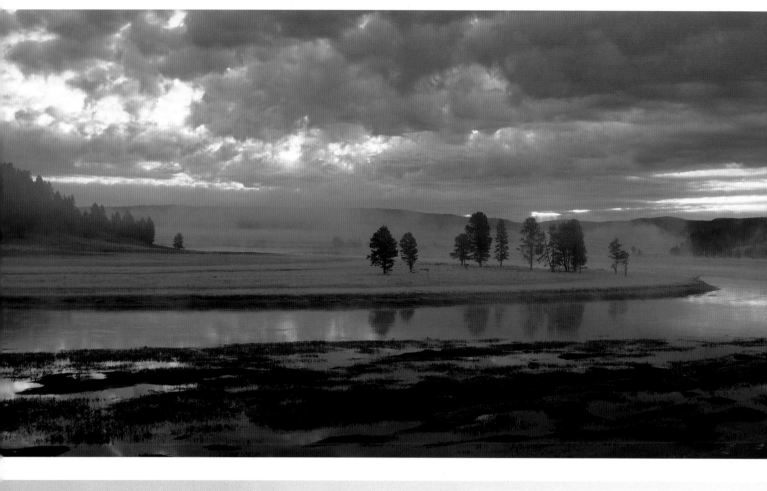

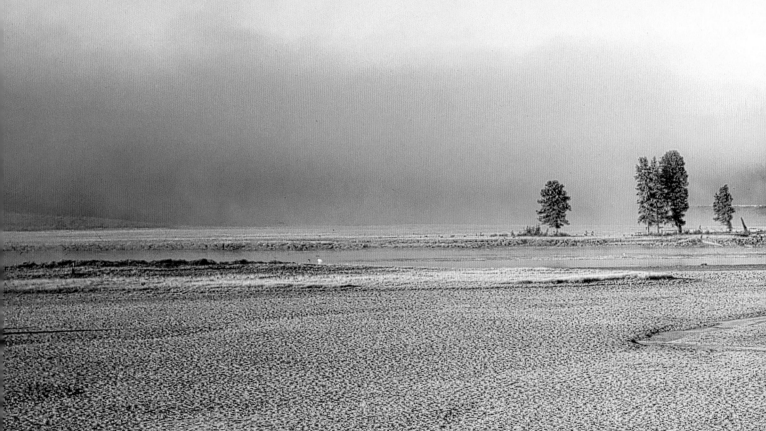

## ALUM CREEK

*Alum Creek is a tributary of the Yellowstone River, which runs through Hayden Valley. At one time the Park Service fenced in bison in this valley so they could be fed in the winter, in an attempt to keep the wild species from the verge of extinction. Today the valley is one of the best areas in which to view the park's rich wildlife, including grizzly bears, bison herds, and coyotes. A wide variety of bird life also flocks to the mud flats along the river's edge. Birdwatchers and wildlife enthusiasts are likely to see sandhill cranes, American white pelicans, and a variety of ducks and geese.*

Below

## HAYDEN VALLEY

*Hayden Valley remains open grassland even in the midst of the forested Central Plateau. The open grassy valley originally lay at the bottom of an ancient glacial lake. The fine sediments that collected on the lake bottom now favor the growth of grasses over trees, helping to maintain the valley's open expanse.*

Overleaf

## YELLOWSTONE RIVER

*A golden dawn rises over the Yellowstone River below Yellowstone Lake.*

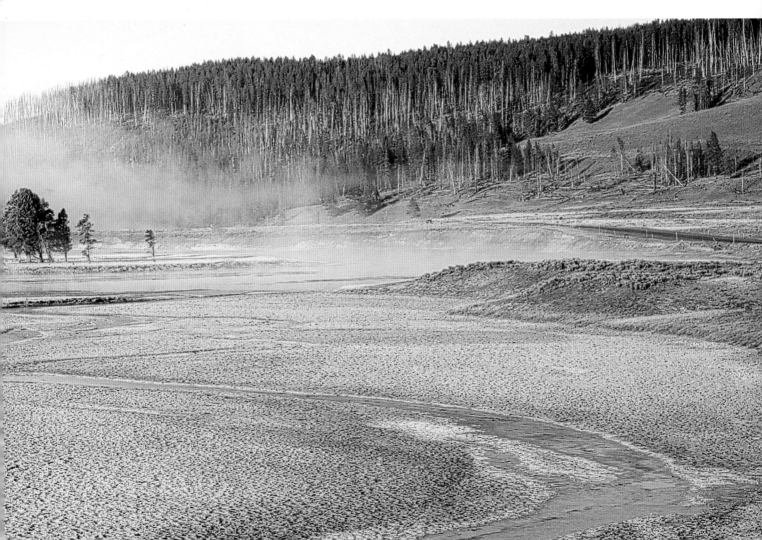

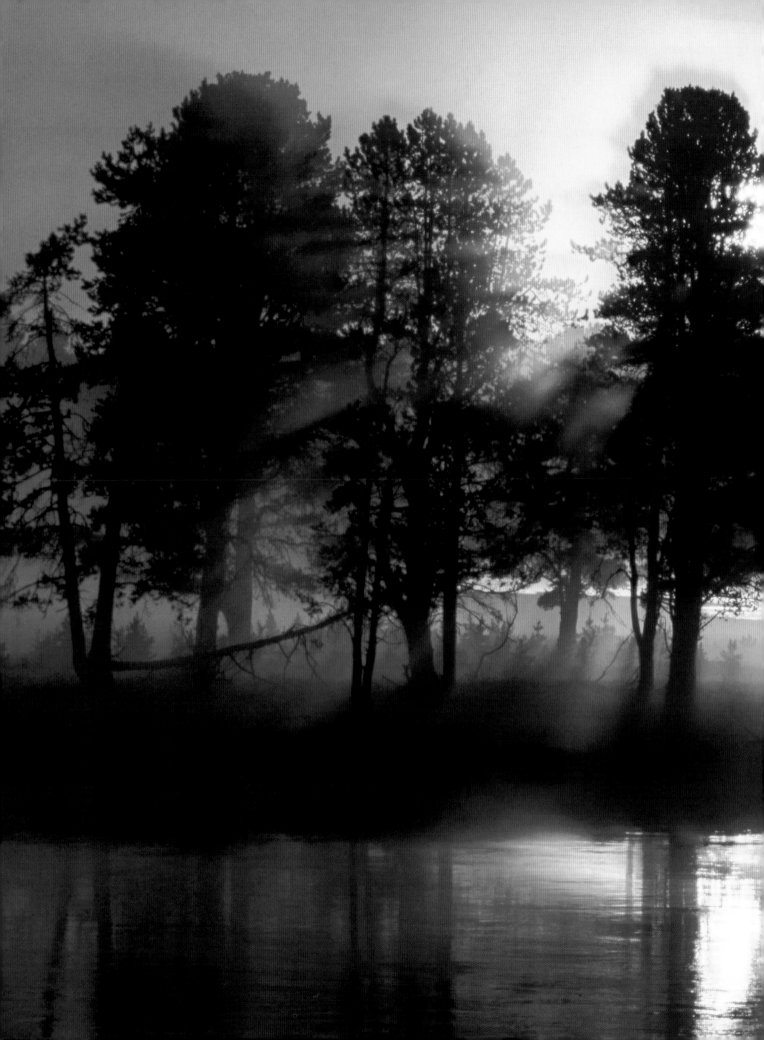

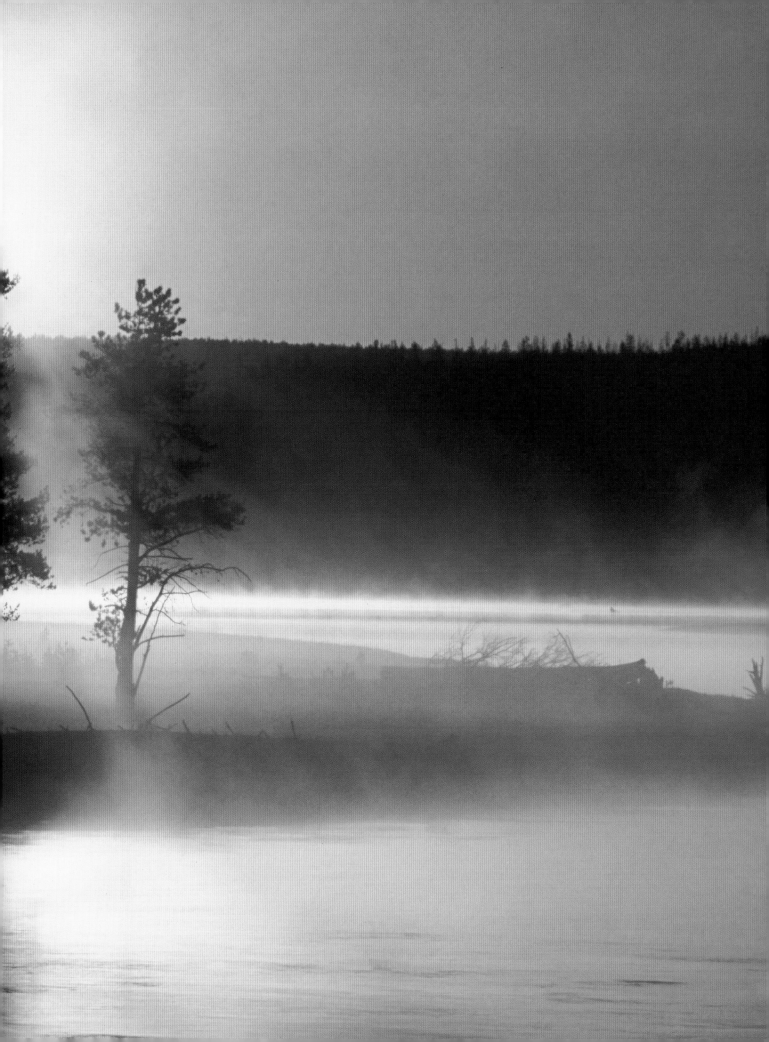

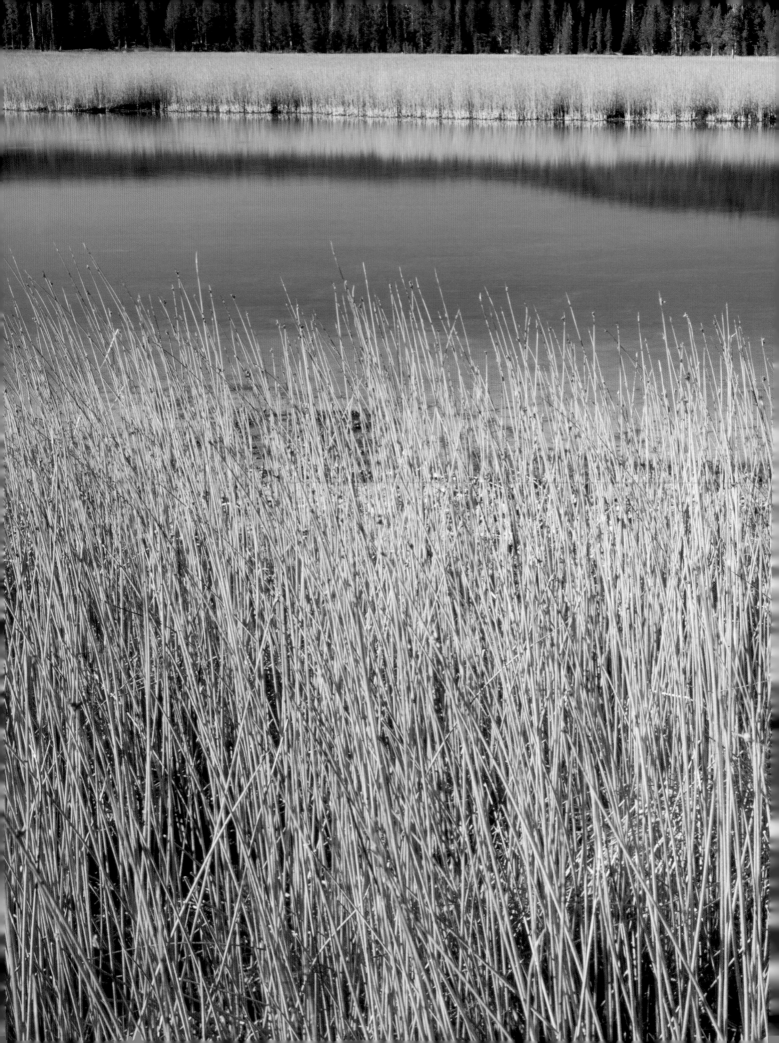

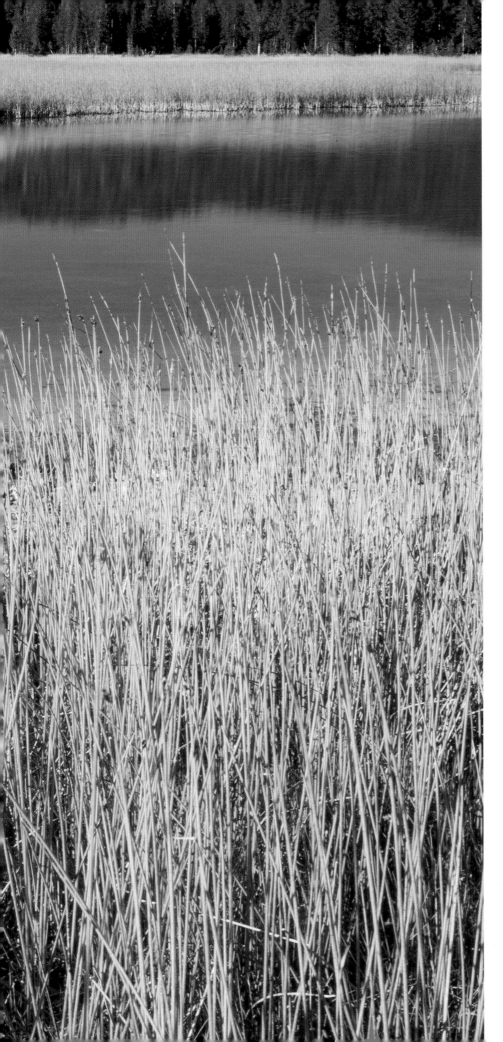

## SHOSHONE LAKE

*Grass along the shore of Shoshone Lake. The 8,000 acre lake is the largest body of water in the lower 48 states that is completely inaccessible by road. Visitors can either choose to hike to the lake or take a paddle boat up from Lake Lewis. Shoshone Geyser Basin can be reached from Shoshone Lake, again by boat, or the more adventuresome and energetic can elect the 8-mile hike from Lone Star Geyser (see page 42). Like Lone Star Geyser, the Shoshone Geyser Basin is renowned for its isolated and therefore pristine location. However, due to its remote setting the geothermal areas are not mapped out with the convenient (and safer) boardwalks as they are in the more accessible parts of the park. But with over 100 geothermal attractions it is well worth making the effort to reach the basin although extra care must be taken when exploring.*

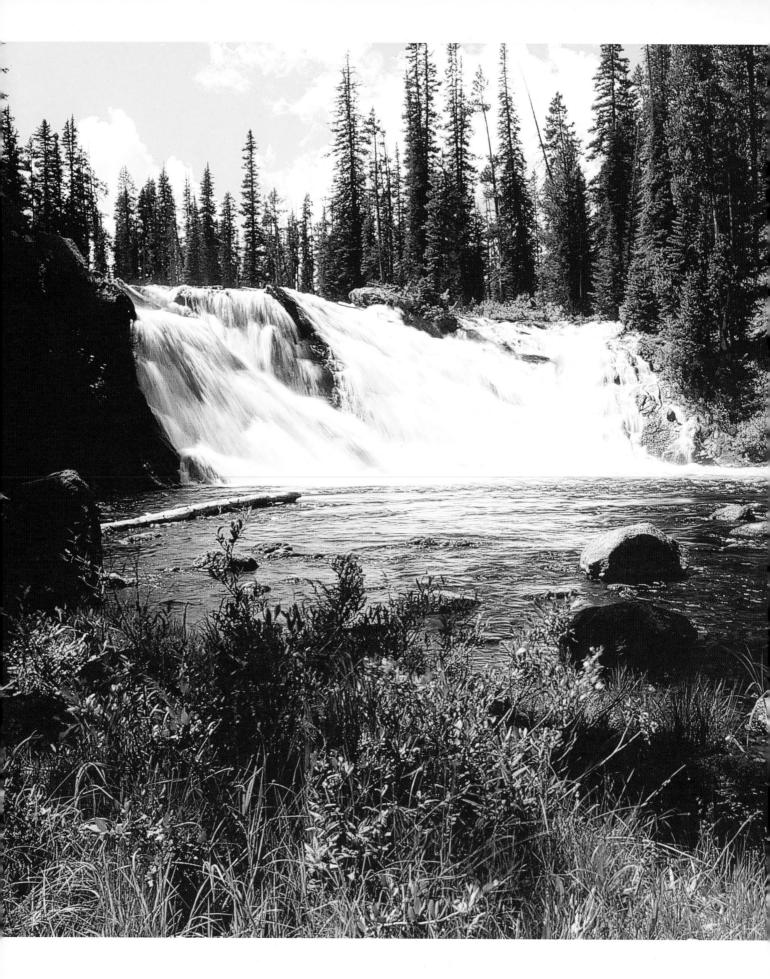

Left and Below

## LEWIS FALLS ON THE LEWIS RIVER

*Lewis Falls is easily reached via a short hike from the South Entrance Road. The falls lie at the southern edge of the Yellowstone caldera and occur as the Lewis River descends a 30-foot drop in its course, flowing out and away from Lewis Lake into the Snake River (one of the major tributaries of the Columbia River). The river is named for Meriwether Lewis of the Lewis and Clark Expedition, and the falls are a popular roadside waterfall attraction at Yellowstone. Due to the easy accessibility of these falls, the hundreds of thousands of visitors who pass through the park's South Entrance every year stop to explore the Lewis Falls trail, and many thousands use the area for picnics and camping. The huge numbers of tourists mean that many new paths have been cut into the surrounding landscapes, damaging the vegetation and native environment. The Yellowstone Park Foundation has instigated a rehabilitation program to help restore the main trail and make it safer for visitors, as well as repair the damage caused to soil and vegetation.*

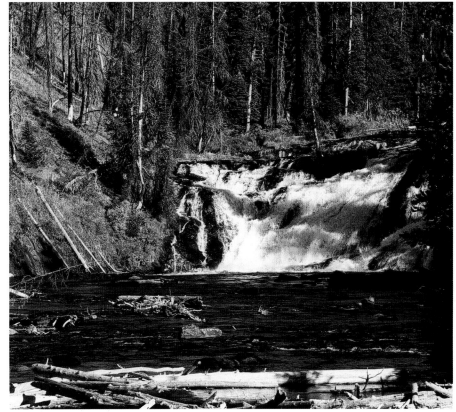

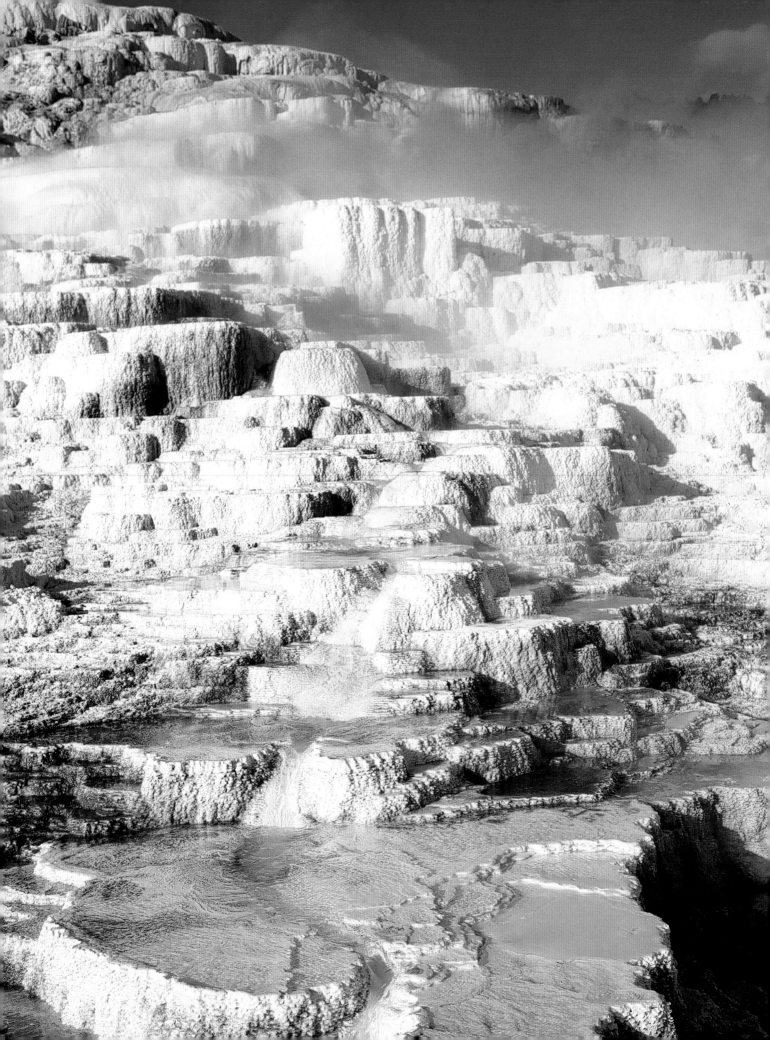

## MINERVA SPRINGS AND TERRACES OF MAMMOTH HOT SPRINGS

*The terraces at Mammoth Hot Springs are created when mineralized calcium carbonate (limestone) in the hot water precipitates out as the water cools, leaving behind the white chalky material known as travertine. The terraces may add as much as two feet of new travertine a year. Mammoth Hot Springs lies outside of the main Yellowstone volcano caldera. All of the other major thermal features in the park sit above igneous rock (volcanic rock), but at Mammoth Hot Springs water percolates up through sedimentary layers of limestone to create these special formations.*

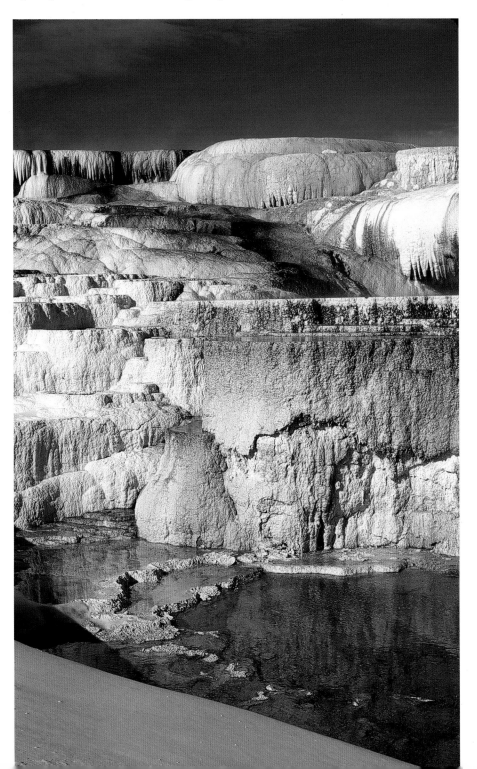

## GARDNER RIVER FROM THE AIR

*The lowest point in the park is by Gardner River. Flowing from the northeast slope of Joseph Peak in the northwest corner of the park, the first sight most people have of this river is from Gardner's Hole. The river starts life as a tiny trickle almost 10,000 feet up but by the time the stream reaches the northwest corner of Gardner's Hole it has been joined by several other small creeks—Fawn, Panther, Indian, and Obsidian creeks— and is a popular family fishing area.*

Below

## MAMMOTH HOT SPRINGS

*Spectacular winter view of Mammoth Hot Springs, looking down through the Gardner River Valley towards the Yellowstone River.*

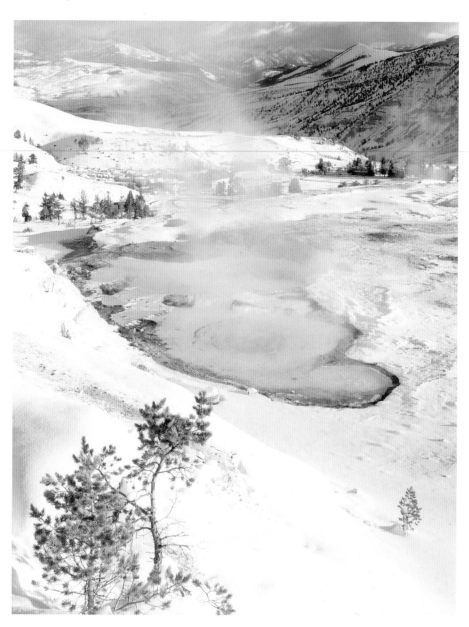

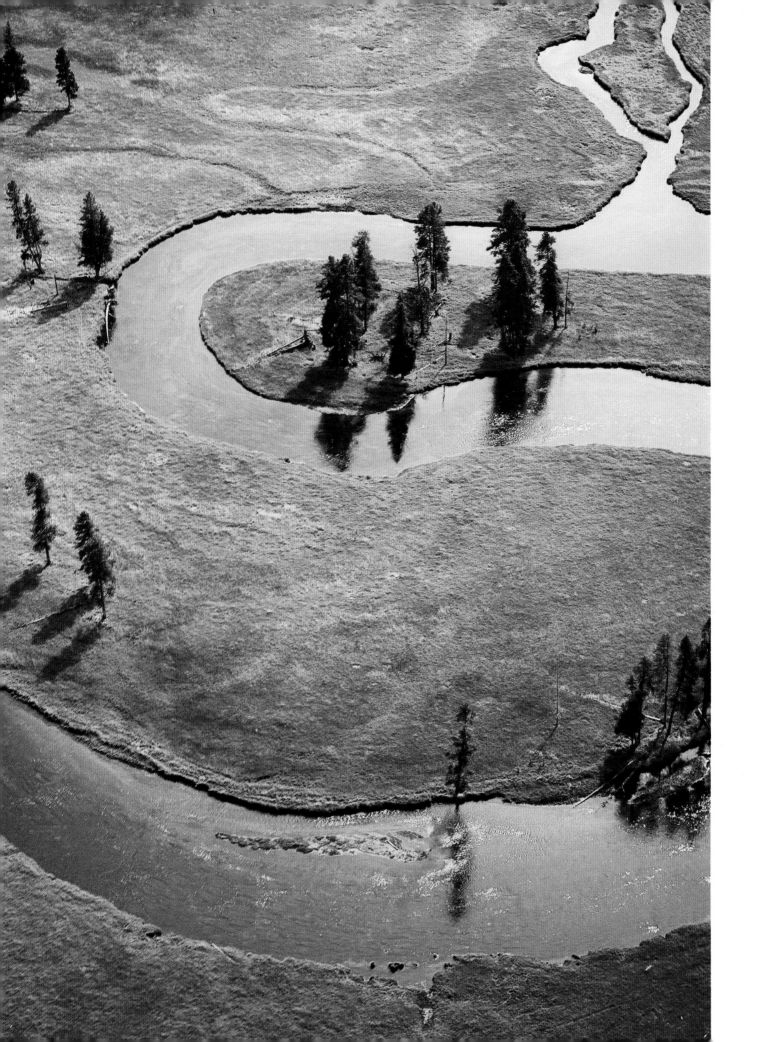

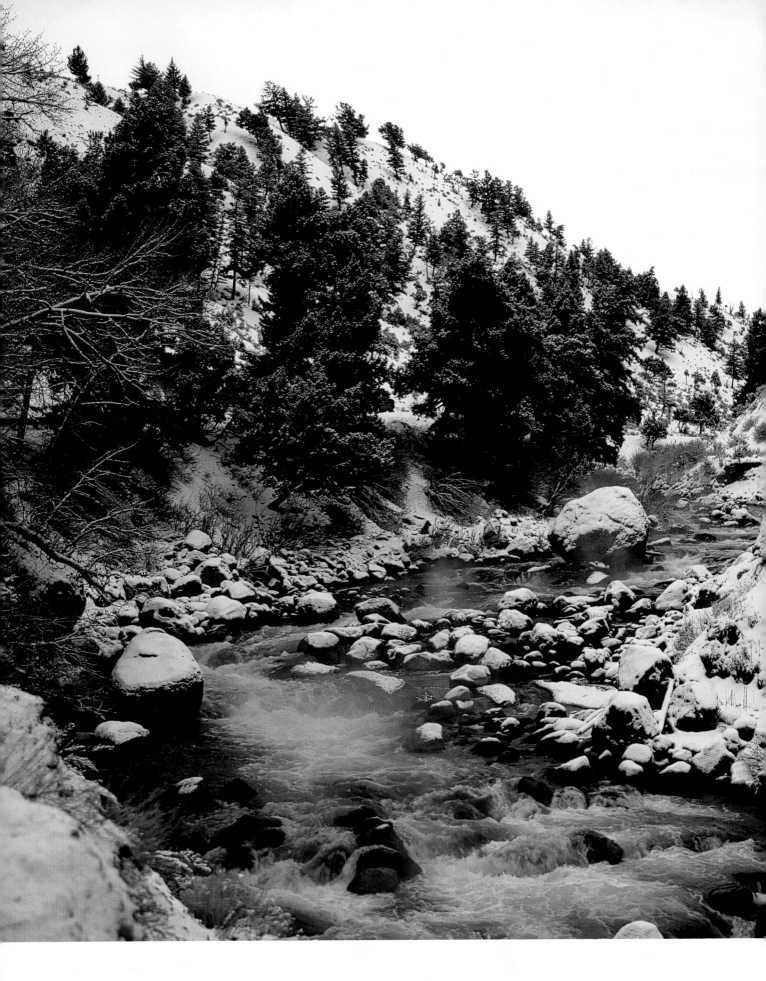

## GARDNER RIVER UNDER SNOW

*Gardiner, Montana; Gardner's Hole; and Gardner River are all named for Johnson Gardner, a fur trapper who worked through the area in the 1830s. (There are two spellings for the name, with and without an "i.") The town of Gardiner was founded in 1880 and the Yellowstone River runs through the center. The site was the original entrance to Yellowstone National Park and today it is the only one that remains open throughout the year. The source of the river is found in the mountains to the west of Mammoth Hot Springs (see pages 58–60), at Joseph Peak. It then flows past Mammoth and north towards the town, where it eventually flows away from Yellowstone.*

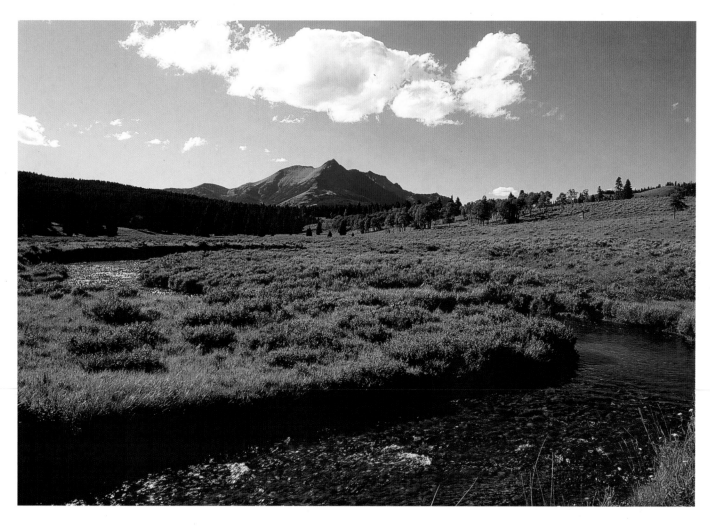

## GARDNER'S HOLE AND ELECTRIC PEAK

*The area of Gardner's Hole refers to the mountain-rimmed valley in which fur trappers once hunted beaver pelts. Electric Peak, the pointed peak that can be seen in the distance, is the highest point in the Gallatin Range which stretches north from Yellowstone Park all the way to Bozeman, Montana.*

Right

## BUNSEN PEAK

*Bunsen Peak is named for Robert Von Bunsen, a German scientist who carried out early research on geysers. (The Bunsen burner is named for him as well.) Bunsen Peak is an old volcanic neck, or feeder, tube for a volcano. The 1,300 foot gradual climb to the summit will reward the climber with a panoramic view of Blacktail Plateau, Swan Lake Flats, the Absarokas mountain range, and the Yellowstone River Valley.*

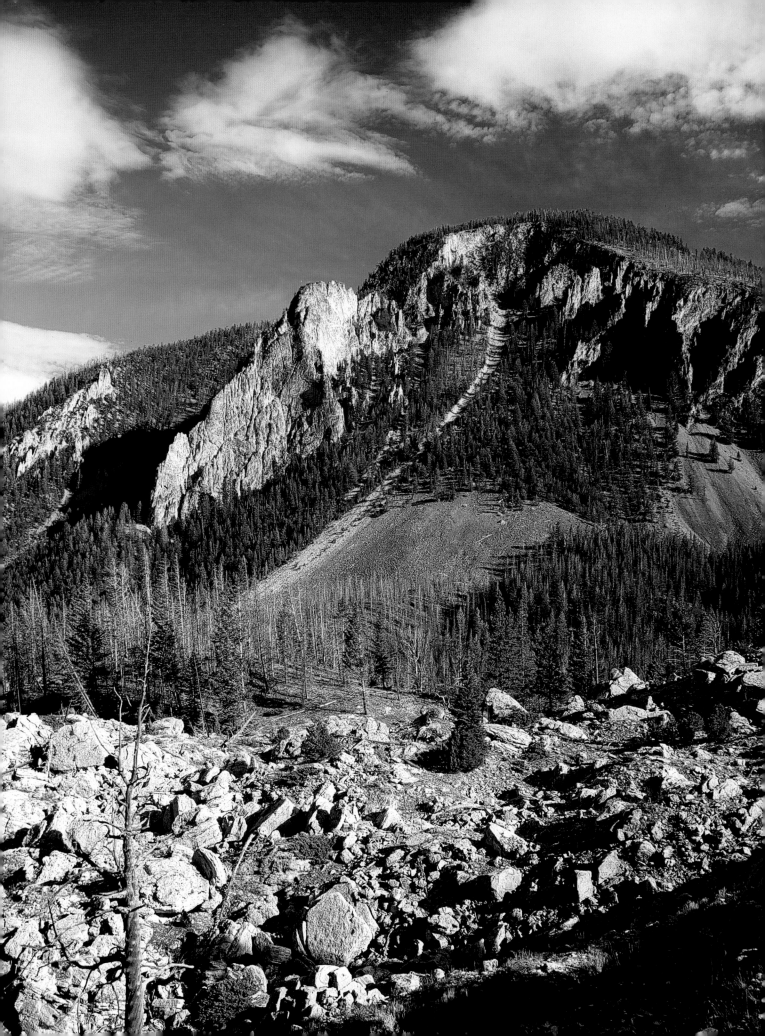

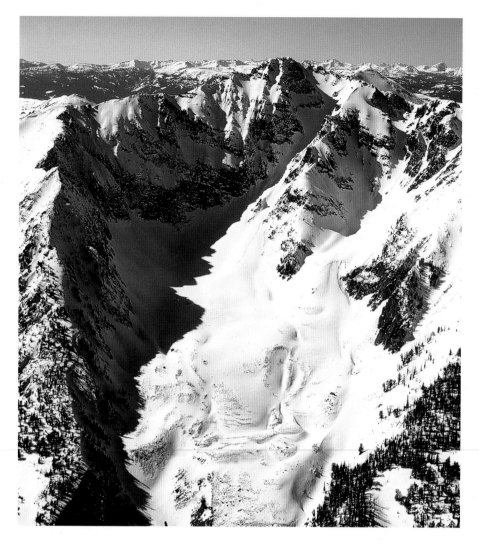

## CIRQUE OF ELECTRIC PEAK

*The bowl-like feature on Electric Peak is in fact a glacial cirque. A cirque is literally carved out of the mountainside by glacial action, which plucks rock away from the mountain and moves it downstream within the ice flow. Glacial action also gives the mountain its ragged appearance.*

## ELECTRIC PEAK

*The highest peak in the Gallatin Range at 10,992 feet, Electric Peak is located 7 miles northwest of Mammoth Hot Springs and can be seen from Swan Lake Flats on the road between Mammoth and Norris—it is the sixth tallest peak in Yellowstone. The Gardner River wanders through this grassy flat before descending rapidly to the Yellowstone River near Gardiner, Montana. This area was known as Gardner's Hole. A hole was any mountain rimmed valley such as Jackson Hole, Pierre's Hole, the Big Hole and so forth.*

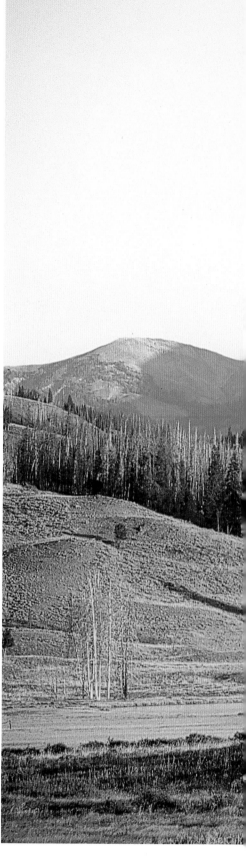

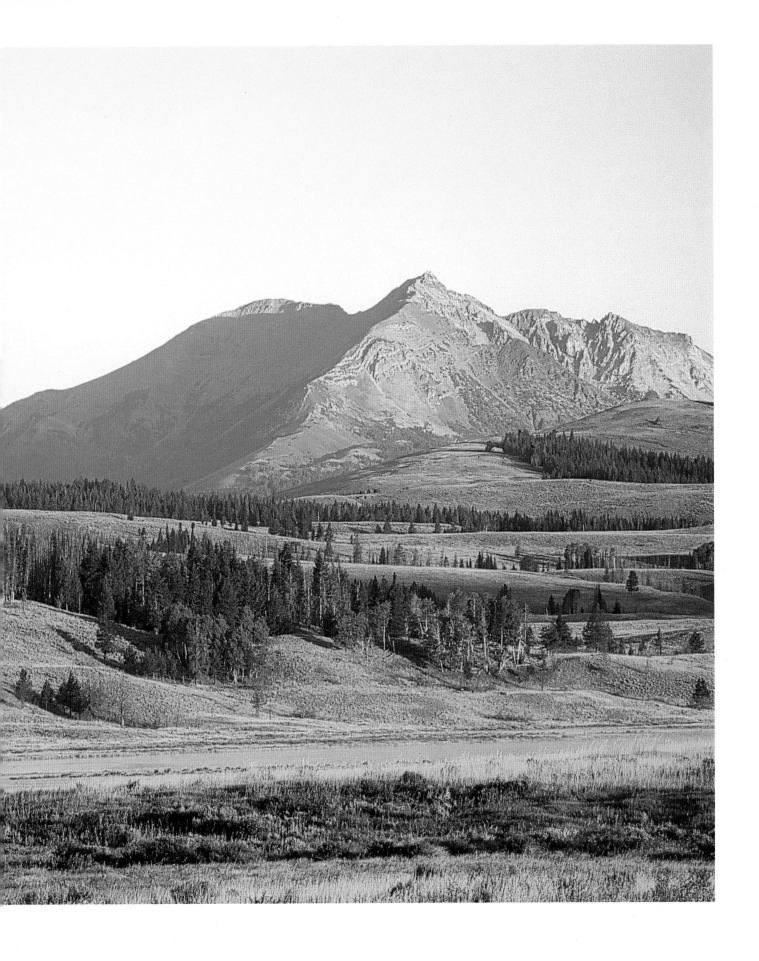

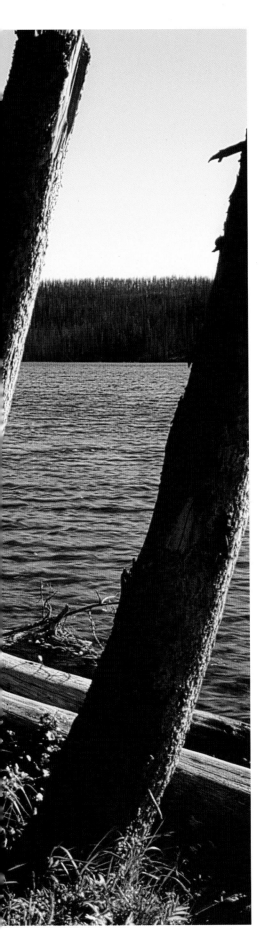

## GRIZZLY LAKE

*Grizzly Lake, in the Gallatin Range, is named for the abundance of bears found in this section of the park. The trailhead for Grizzly Lake lies between Mammoth and Norris. The lake is a short two mile hike from the highway and is reported to be good fishing for brook trout. Most of the trail to the lake passes through snags of trees charred by the 1988 fires. The summer of 1988 was one of the driest in the park's history. A natural fire policy had been instigated in the park in 1972 as many of the plant species in the parkland were fire adapted and natural fires were often left to burn themselves out in order to help increase plant productivity. However, that season saw 793,000 acres (around 36 percent of the park) scorched. A huge fire-fighting effort was launched to stop the fires, but by mid-September autumn snow falls had dampened the fires, and the imminent danger had passed.*

Below

## MOUNT EVERTS

*Most of Yellowstone Park was buried under glacial ice during the last Ice Age. Glaciers carried rocks and boulders miles from their orignal source, eventually dropping them when the ice melted and the glaciers receded. Some of those out-of-place boulders, or "erratics," are seen here on top of Mount Everts, near Gardiner.*

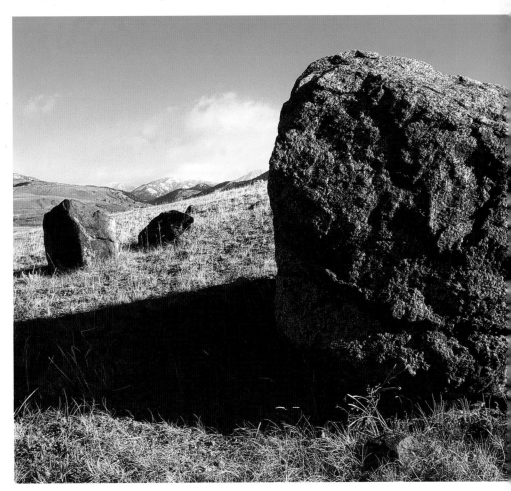

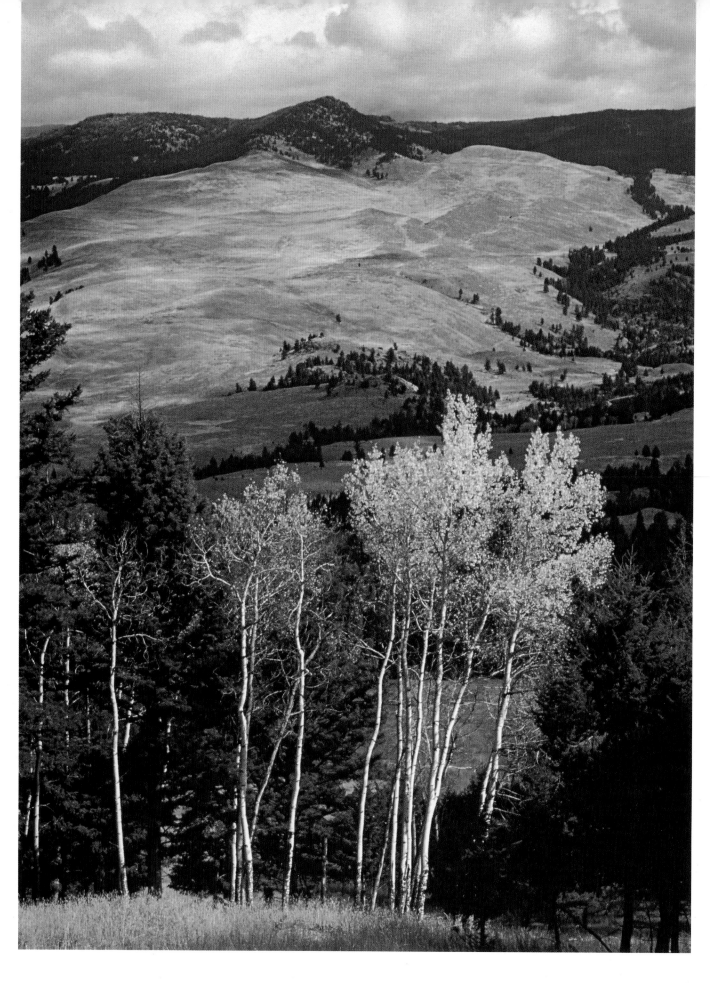

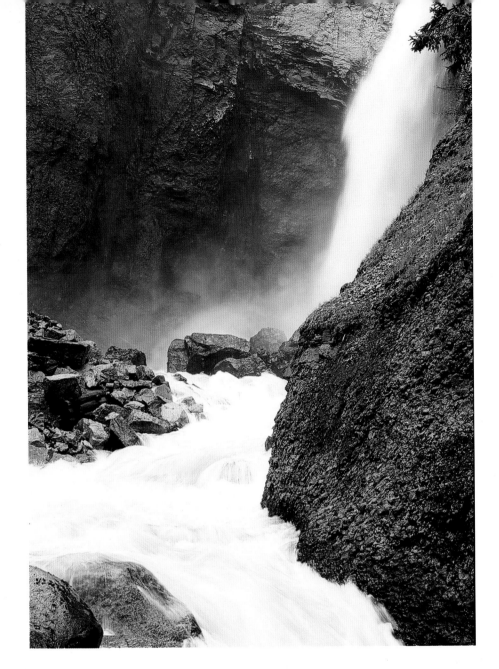

Above

## TOWER FALLS NEAR TOWER JUNCTION

*The 132-foot falls were left hanging above the Yellowstone River because the river's small volume reduced its ability to erode away the bedrock as quickly as the main river, leaving the tributary stream "overhead" to create a falls. The Washburn Expedition named the falls in 1870 after the numerous pinnacles and "towers" of eroded rock that surround the falls.*

Left

## ASPEN ON BLACKTAIL PLATEAU IN AUTUMN

*Aspen tend to sprout from root suckers so often all the aspen in a particular grove are genetically related, budding out at the same time in the spring and then turning gold at the same point in the autumn. Blacktail is also a haven for a large diversity of wildlife.*

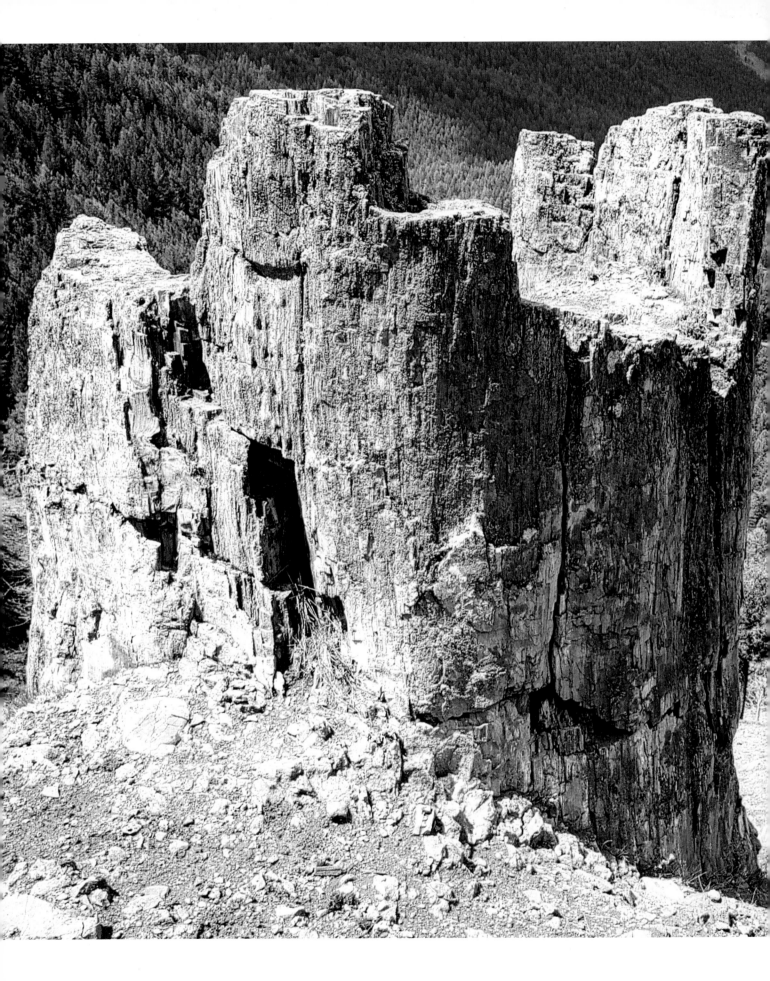

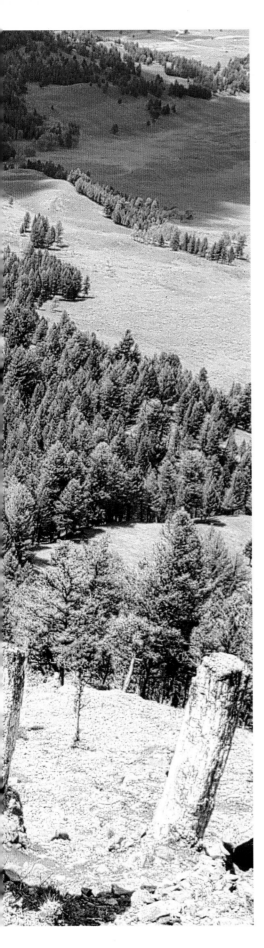

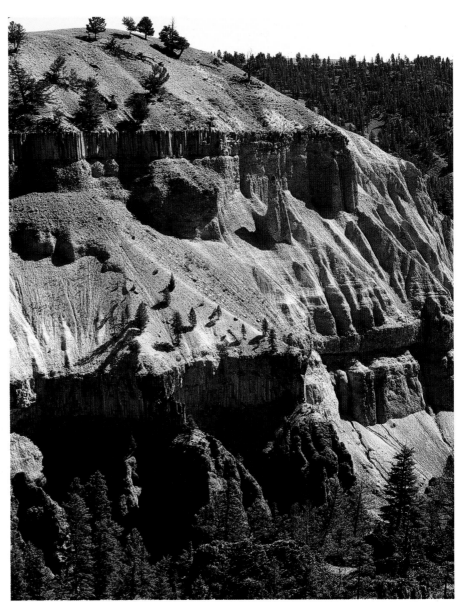

Above

## CLIFF NEAR TOWER JUNCTION

*Basalt flows alternate with gravels in this cliff side near Tower Junction. These are fine examples of columnar jointing which is formed when lava cools and shrinks, creating polygonal patterns. The lava flows are interspersed with sedimentary gravels formed when the lava was buried under river cobbles.*

Left

## SPECIMEN RIDGE

*Petrified redwood trees on Specimen Ridge. At one time redwood and other trees associated with a milder climate flourished in the Yellowstone region. Volcanic eruptions buried the trees, standing upright, and petrified them, effectively turning them into solid rock specimens.*

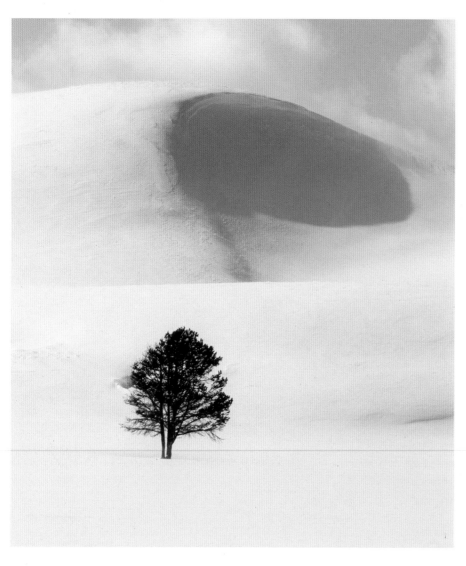

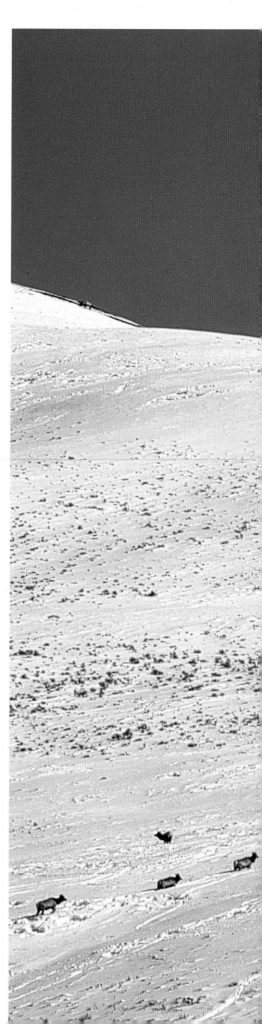

Above

## LAMAR VALLEY

*A lone tree among the snow-covered hills of the Lamar Valley waits out the freezing grip of winter in the park. The Lamar Valley is one of the most beautiful and most popular places in the park for watching wildlife. Readily seen in the open grassy landscape are elk, pronghorn antelope, bison, grizzly bear, and wolf. The valley was named in 1885 for Lucius Lamar, Secretary of the Interior.*

Right

## ELK ABOVE THE VALLEY

*Elk herd feeding on a slope above the Lamar Valley with a full moon rising beyond. The valley is located in the Northeast corner of the park, just east of Tower-Roosevelt. It boasts the largest concentration of grizzlies in Yellowstone, and a patient watcher will often be rewarded with a rare sighting. Lamar is also the best area in the park to see wolves. Early mornings and late evenings are the ideal time to view the area's wildlife.*

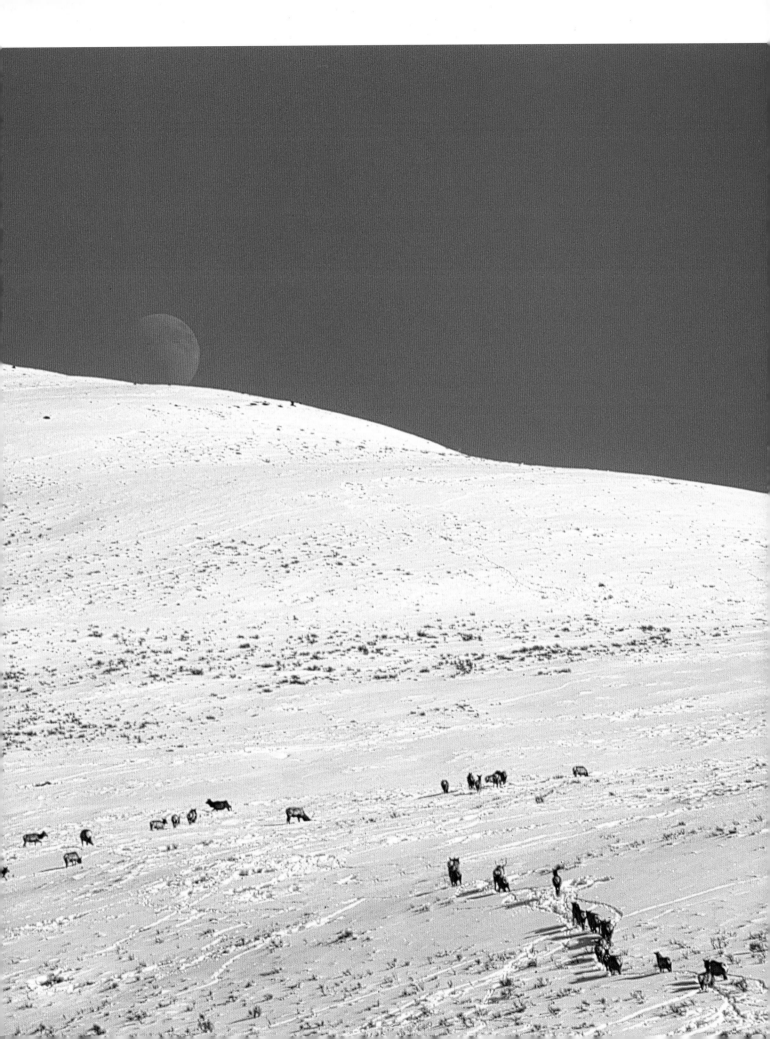

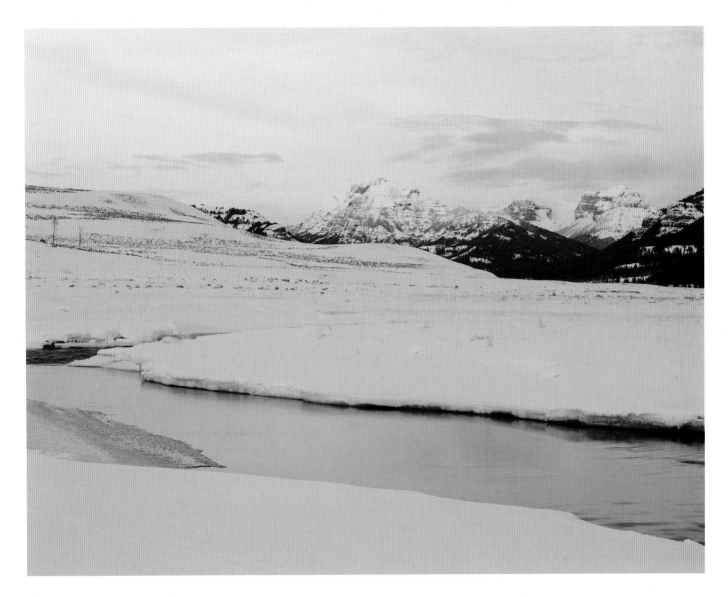

## SODA BUTTE CREEK

*A spectacular mid-winter wonderland. Soda Butte Creek is pictured here as it flows majestically through the frozen Absaroka Mountains near the Park's northeast entrance, close to Cooke City, Montana. The creek originates by Henderson Mountain near the city and flows through the northeast corner of the park for approximately five miles before it joins with the Lamar River (a tributary of which can be seen flowing through the background of the picture opposite).*

Left

## SLOUGH CREEK

*A snag frames the meadows at Slough Creek, a tributary of the Lamar River. Slough Creek gets its name from the meandering course it follows through multiple meadows. Famous for its large and visible Yellowstone cutthroat trout, the creek is a mecca for fishermen.*

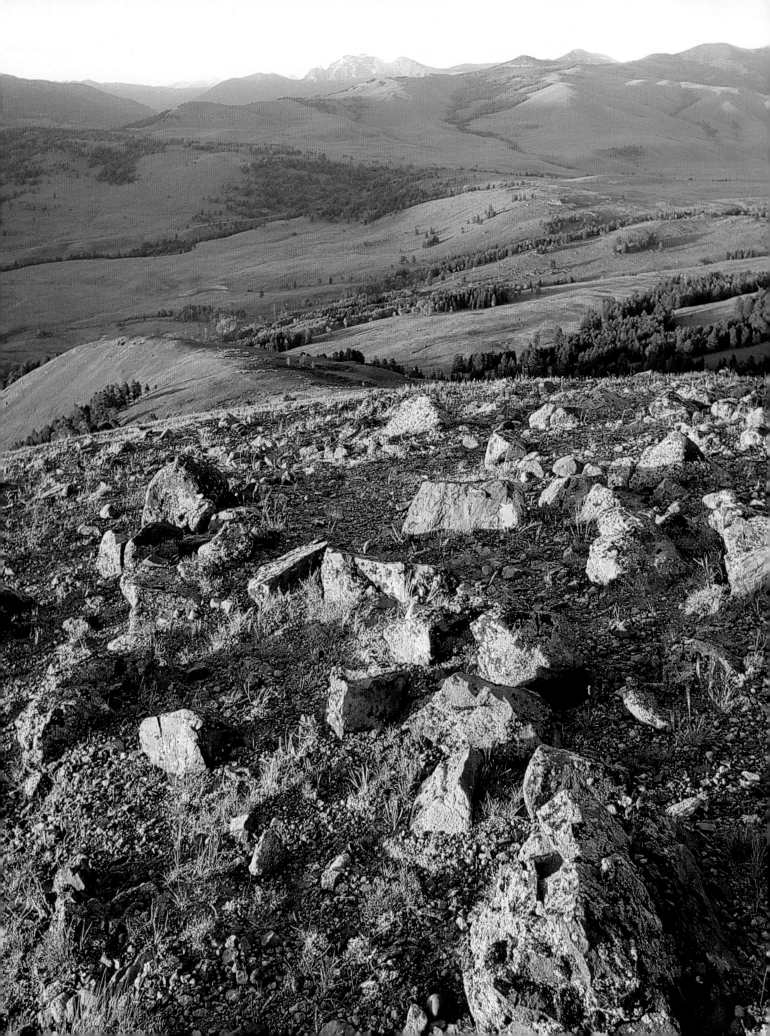

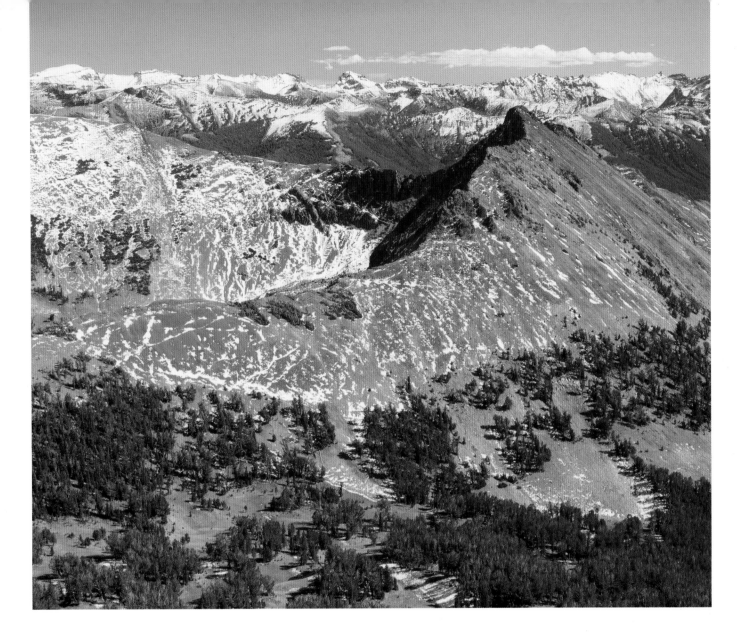

## ABSAROKA MOUNTAINS

*A view of the Absaroka Mountains from Avalanche Peak along the park's eastern*
*border. The Absaroka Mountains are named for the Crow Indians whose name,*
*Absarokee, was interpreted as meaning crow. Part of the Greater Yellowstone Ecosystem,*
*it is home to grizzly bears, elk, and a vast array of other wildlife.*

Left

## CUTOFF MOUNTAIN

*Specimen Ridge separates the Lamar Valley from the Mirror Plateau. This view, taken*
*from its long ridge summit, looks north towards the Lamar Valley and Cutoff Mountain.*
*Specimen Ridge is named for the numerous petrified trees found on its slopes.*
*The wind-blown grassy ridge is also grazed in winter by bighorn sheep and elk.*

Above

## ABSAROKA RANGE

*The Absaroka Range forms the eastern boundary of the park and is a segment of the Rocky Mountains on the eastern side of the range. The sub-range stretches across the Montana-Wyoming border for about 150 miles. The Absaroka includes several peaks over 12,000 feet, and rises to 13,153 feet at its highest point, Francs Peak. A sub-range of the Absaroka Range, Beartooth Mountains, includes Granite Peak which reaches a height of 12,799 feet and is the highest point in Montana. Much of the Absaroka Range is protected by a number of conservation areas which include Yellowstone National Park, the Absaroka-Beartooth Wilderness Area, North Absaroka Wilderness Area, Teton Wilderness Area, and Washakie Wilderness Area.*

Right

## WEST THUMB OF YELLOWSTONE LAKE

*Varves created by past glacial lake deposits are seen here along the shore of Yellowstone Lake's West Thumb. Such layering resulted from the rapidly changing shoreline level of the lake during the Ice Age. Glacial silt poured into the lake creating the stepped formations visible here. Each varve consists of two distinct layers of sediment, a lower layer of light colored sandy deposit and an upper layer of darker silt. A new set of layers were formed each year and by counting them the age of the lake can be established.*

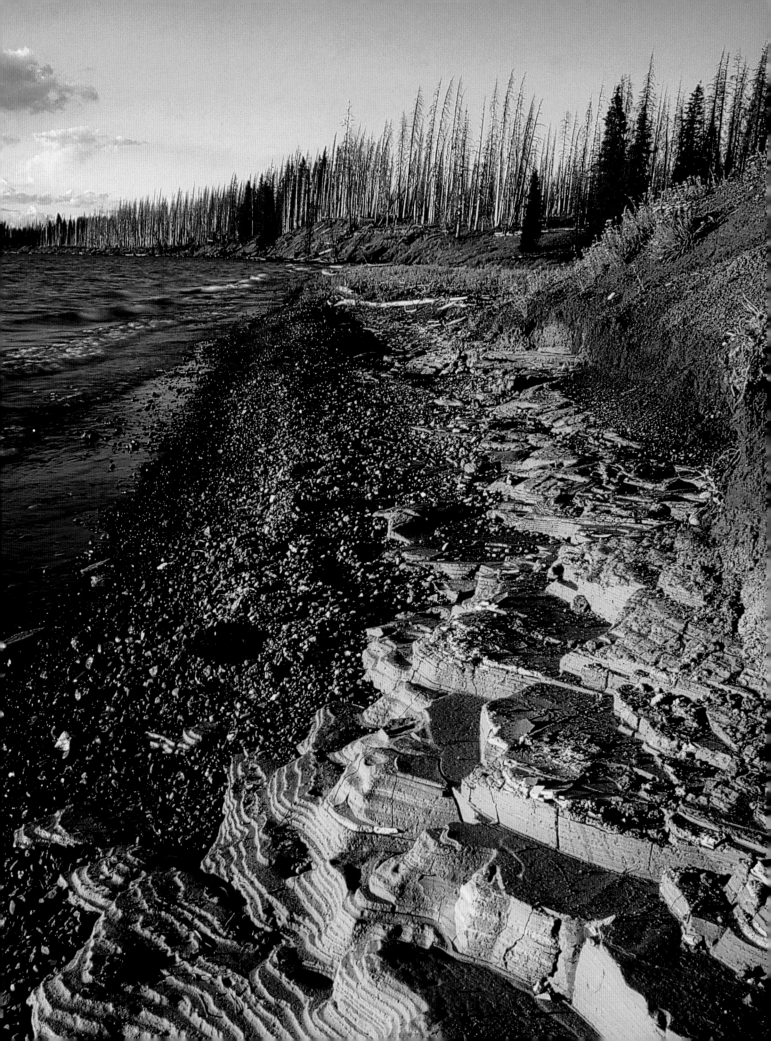

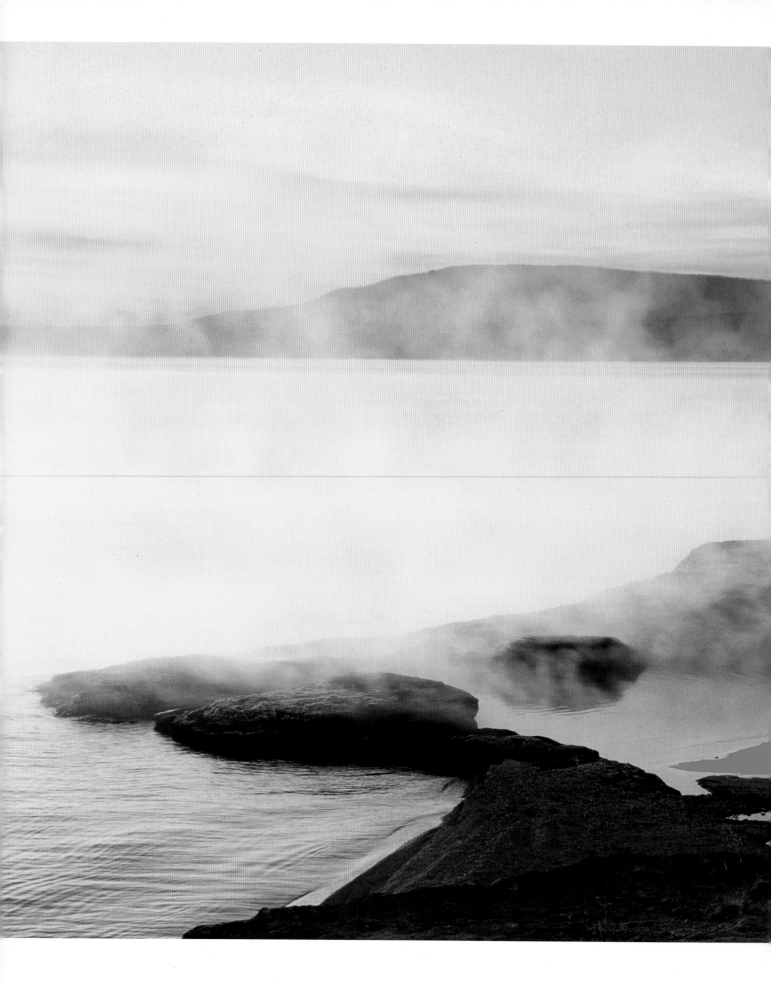

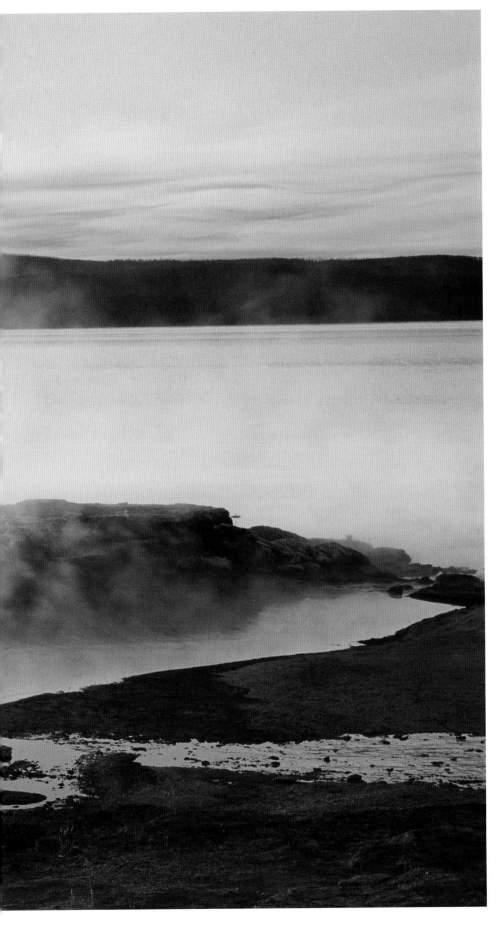

## YELLOWSTONE LAKE

*Yellowstone Lake fills the caldera of the old Yellowstone volcano, which exploded some 600,000 years ago. Scientific mapping of the lake floor, carried out since 1999, has revealed a series of hot springs, faults, and craters scattered across the lake bed. One of these is reportedly a bulge or "inflated plain" some 2,000 feet in length and approximately 100 feet above the lake floor. Seismic images of the irregularity, and others like it under the lake, appear to indicate that these have been caused by the accumulation of gas from the area's hydrothermal activity. However, it is thought to be very unlikely that these features will be the sight of imminent hydrothermal explosions or volcanic eruptions.*

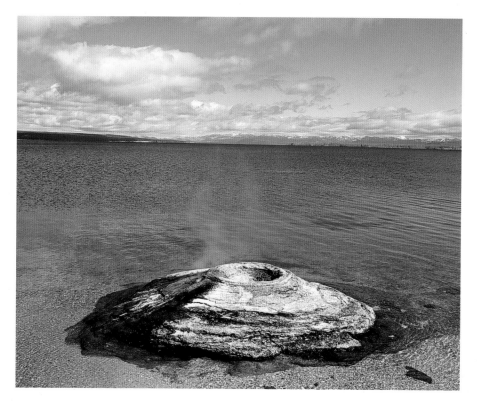

Above

## FISHING CONE

*Fishing Cone is part of the West Thumb Geyser Basin. In the old days it was said that people could catch trout in the lake, and then without removing them from the hook, stick them into the hot thermal waters of Fishing Cone and cook them on the spot. Fishing Cone is a geyser that has erupted in the past, so getting too close could be dangerous. It is now illegal to perform this "cast, catch, and cook" feat.*

Right

## YELLOWSTONE LAKE

*Yellowstone Lake is the largest high elevation lake in the United States. Except for some minor development on its northeastern shore, the lakeshore is near wilderness. Because of thermal features in its depths, the lake is more productive than similar high elevation lakes, and supports one of the last remaining healthy populations of Yellowstone cutthroat trout in the world. However, the introduction of exotic lake trout now threatens the survival of the lake's native fish population.*

Overleaf

## WEST THUMB GEYSER BASIN

*Hot springs at West Thumb, one of the smallest yet most scenic geyser basins in the park. There are six geysers in the West Thumb group, but most of them are no longer active.*

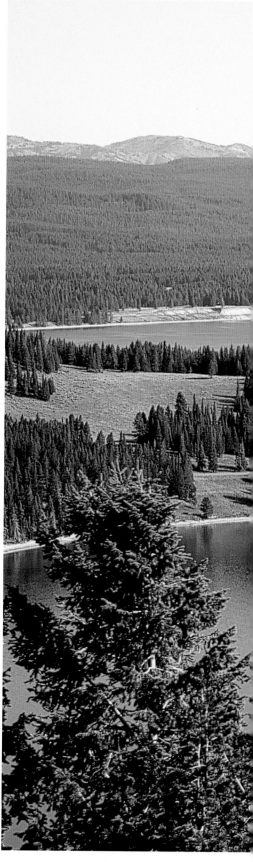

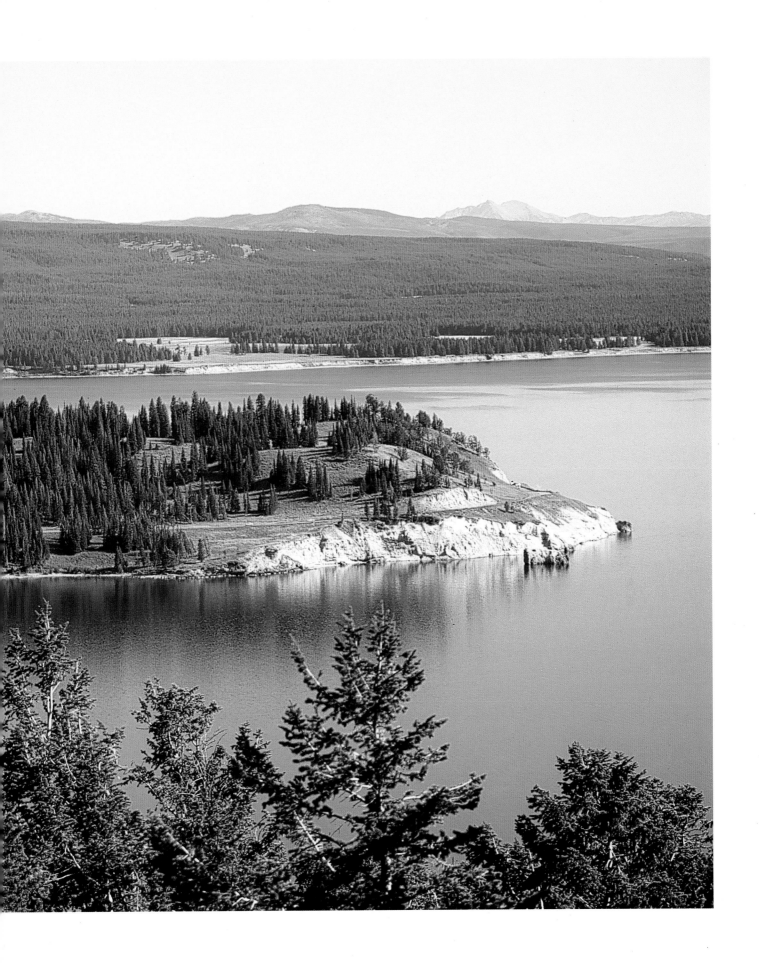

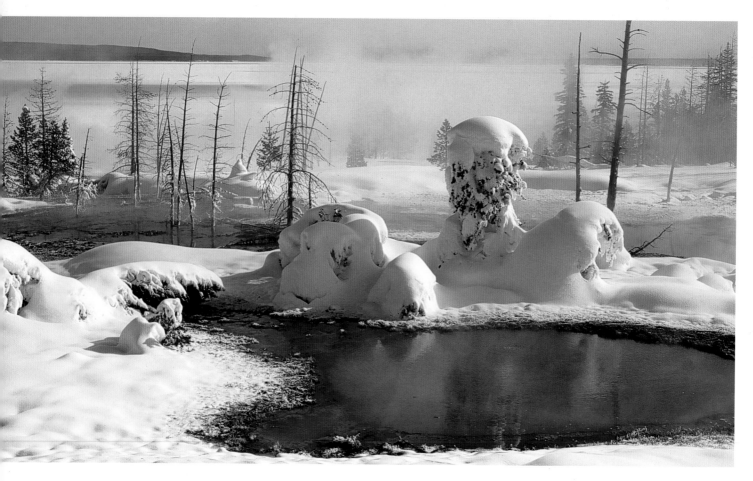

Above

## WEST THUMB GEYSER BASIN IN WINTER

*The West Thumb Geyser Basin sits along the shore of the West Thumb of Yellowstone Lake. It is an explosion caldera formed about 162,000 years ago. The name "West Thumb" refers to the shape of Yellowstone Lake, which was thought to resemble a hand, with the bay in front of the geysers representing the thumb, and the south and southeast arms the fingers.*

Right

## GRIZZLY BEAR CUB

*The grizzly bear (*Ursus arctos horribilus*) is a subspecies of brown bear (*Ursus arctos*). The largest and most stable populations of grizzlies can be found in Canada and Alaska. However, in the lower 48 states, approximately 1,200 grizzlies still live in the wild, and the Greater Yellowstone Ecosystem and Glacier National Park are home to the majority of those. This fragile grizzly population is currently protected under the Endangered Species Act. The most critical issue in the protection of grizzlies is the preservation of enough undisturbed wilderness for them to survive. Grizzlies range throughout Yellowstone and there are several sites that offer good bear-spotting opportunities including the Dunraven Pass area, just past the turn-off to Mount Washburn, across the Yellowstone River in Hayden Valley, in the Fishing Bridge area, and also in Lamar Valley. As the number of visitors to the park increases each year greater efforts are required to help preserve the bears' habitat and therefore their population.*

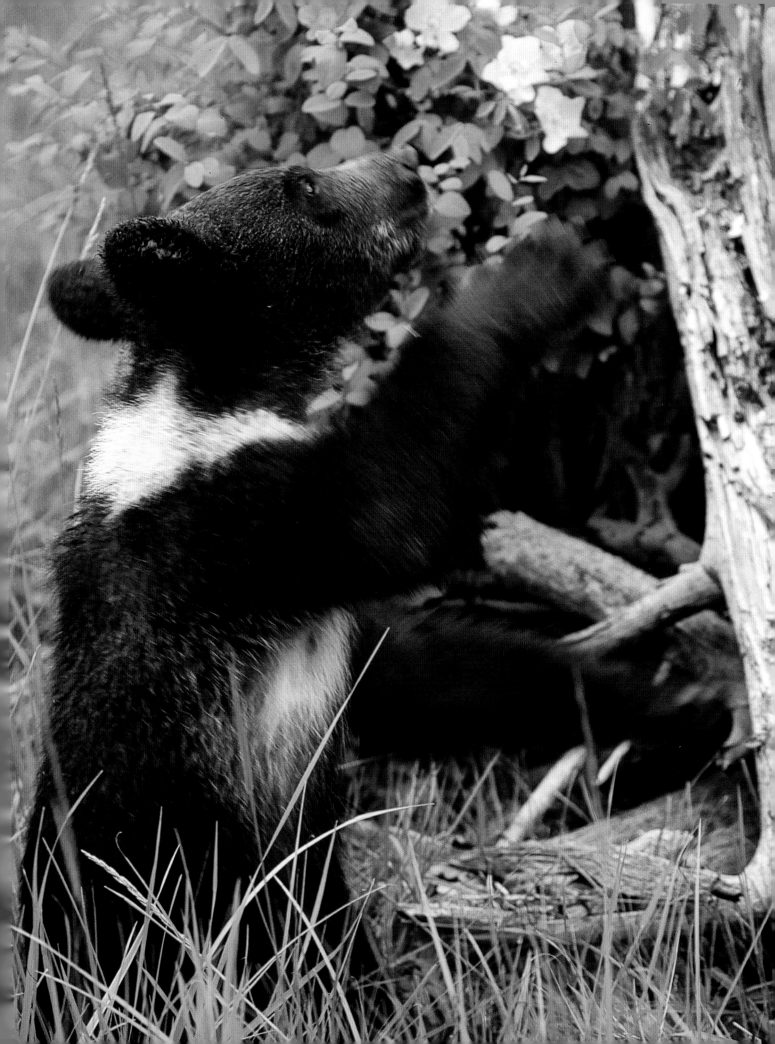

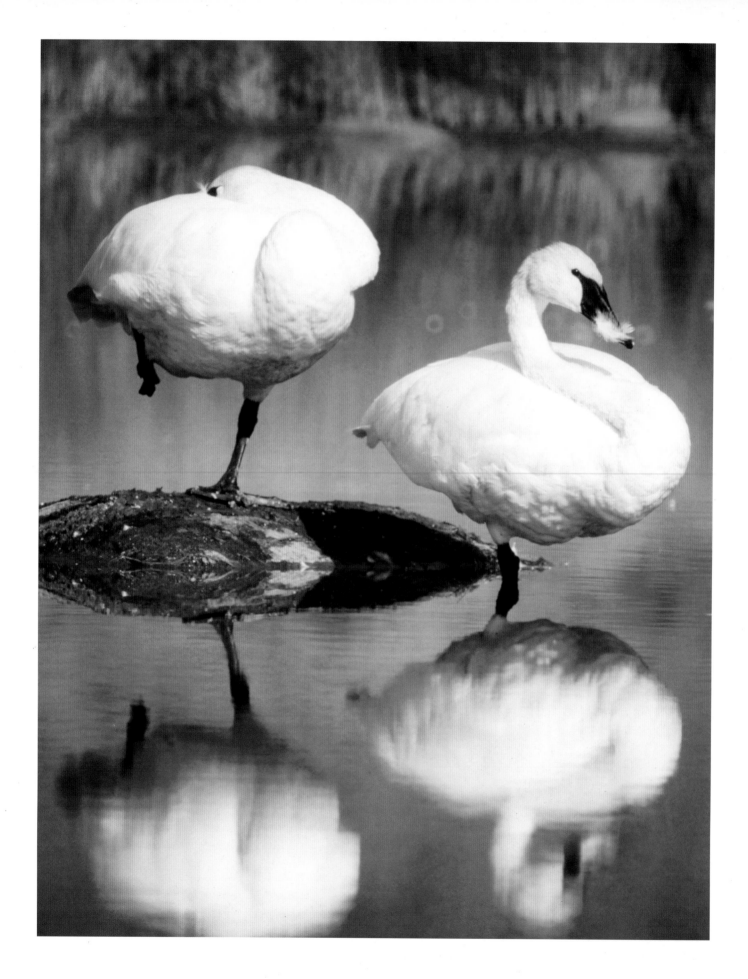

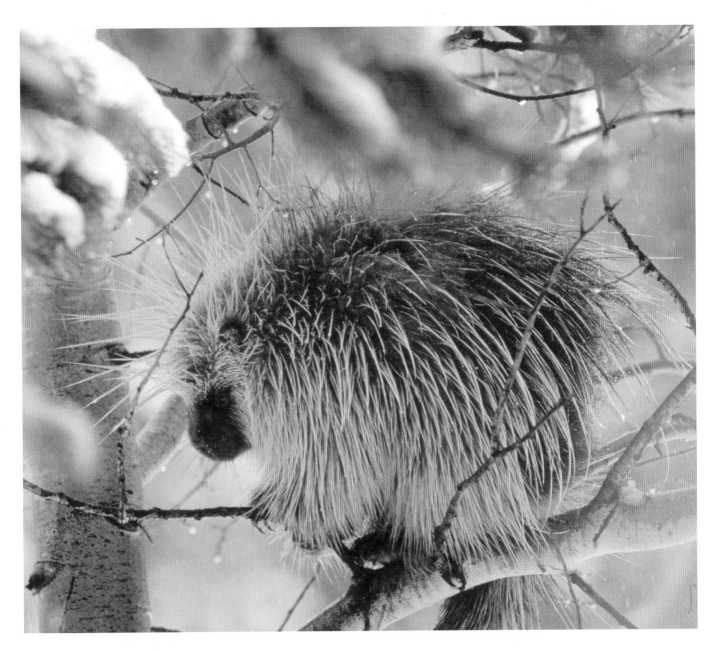

## PORCUPINE

*One of the park's many herbivorous inhabitants. Porcupine quills are enough to discourage almost all but the most determined and foolhardy predators.*

## TRUMPETER SWANS

*Trumpeter swans in the Greater Yellowstone Ecosystem often winter along the park's thermally heated streams, where they graze for water plants below the surface. The swans were once feared to be verging on extinction with only a small group surviving in Yellowstone. Today, due to proactive conservation programs, the swans' population has reached about 20,000 and can once again be found across North America. The park is now home to two different populations of the Trumpeter swans.*

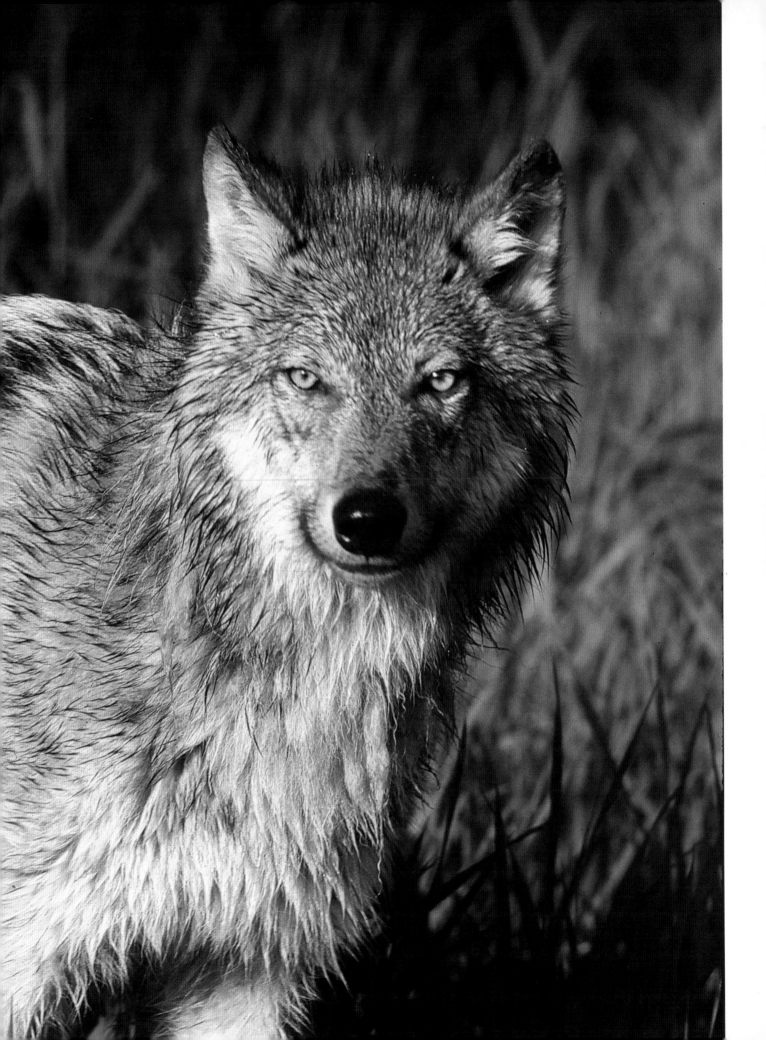

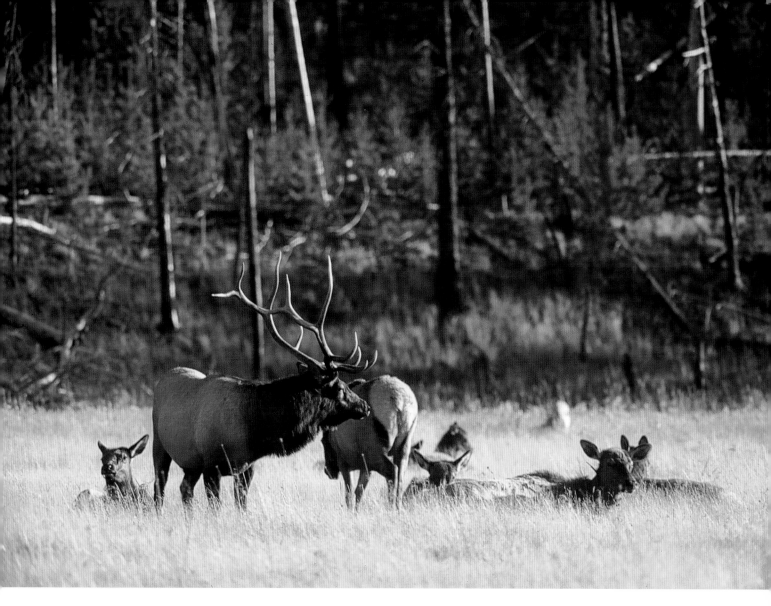

## ELK

*The American elk are in fact a member of the deer family. An adult elk can weigh up to an impressive 770 pounds, stand 5 feet high at the shoulders, and measure in the region of 8 feet long. A full grown male's antlers can also span more than 5 feet.*

## GRAY WOLF

*The Northern Rocky Mountain wolf is a sub-species of the gray wolf and was once native to the Yellowstone area. Predator control measures were introduced soon after the establishment of the park in 1872, and by the 1930s the gray wolf had disappeared completely from the park. However, after many years and extensive lobbying the National Parks Service was able to gradually reintroduce the gray wolf back to Yellowstone, beginning with controlled releases in 1995 and 1996. The wolf population is now well on its way to recovery and many visitors to the park are able to view these magnificent creatures in their native habitat once again.*

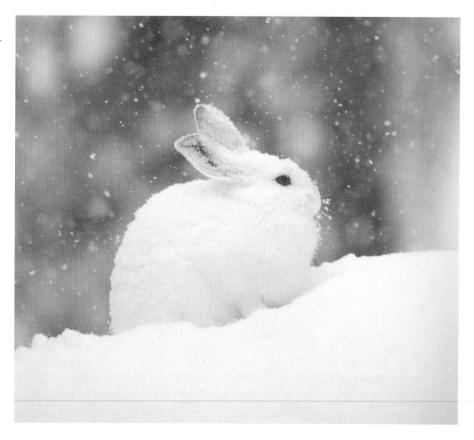

## SNOWSHOE HARE

*The snowshoe hare is named for its comparatively large feet (4–6 inches long). The soles of their feet are furry and, with the toes spread apart, the hare is exceptionally well adapted for traveling on top of snow. The snowshoe is also noted for changing color; in the winter its fur is almost entirely white but in the summer their fur changes to a grayish-brown. The snowshoe can run up to 27 mph and can jump 10 feet in one hop. It is found in northern regions of the United States and most of Canada. They live in tundra, taiga, open fields, forests, and along riversides and swamps which makes the diverse terrains offered within Yellowstone the ideal habitat for these attractive creatures.*

## BISON IN SNOW

*Bison are able to survive through Yellowstone's long winters by feeding on grasses made more accessible by thermal features, where snow depth is reduced. The availability of more easily accessible grazing areas means that the bison do not have to use valuable calories in an effort to clear snow from their feed and therefore enable them to conserve vital energy necessary to survive the harsh winter season.*

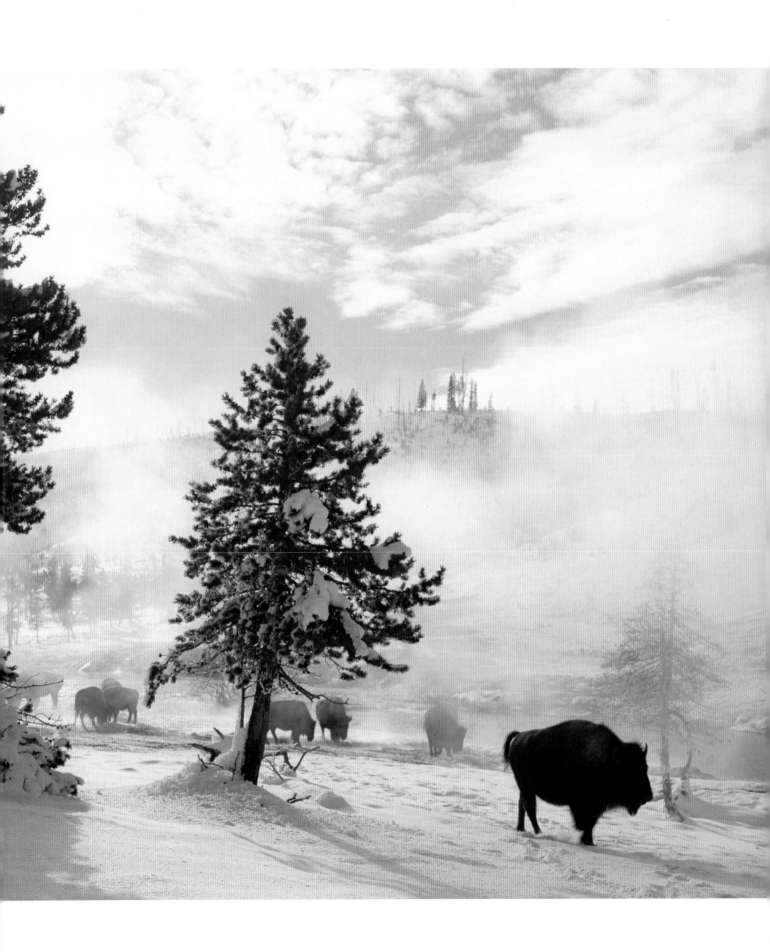

# INDEX